AARON TURNER

THE HOT CHICKEN PROJECT

PHOTOGRAPHY JULIAN KINGMA

Hardie Grant

BOOKS

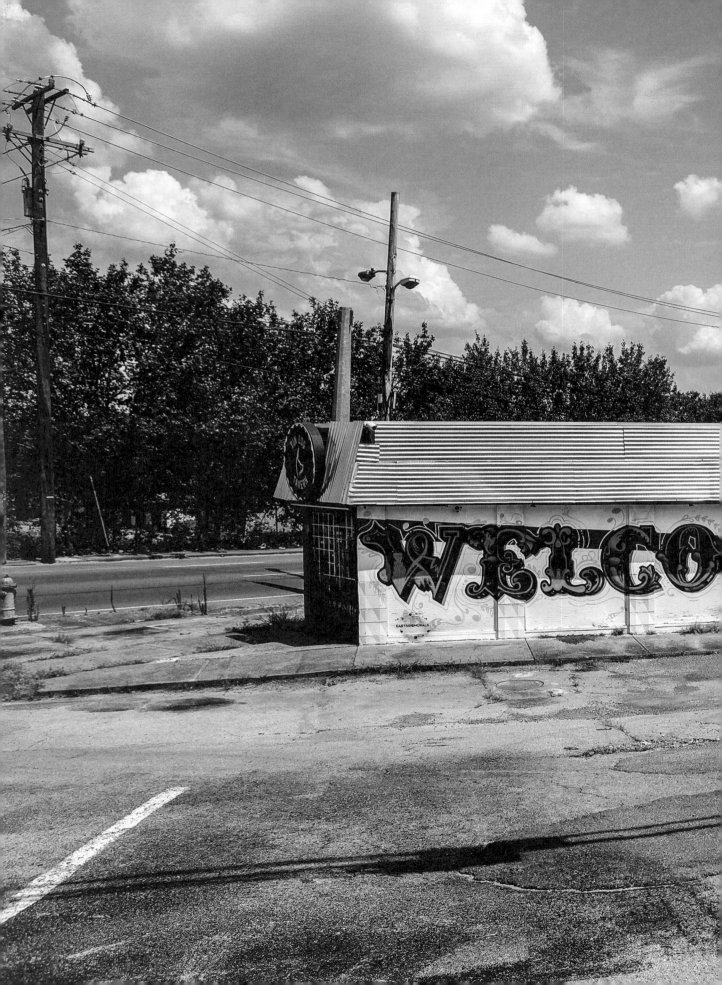

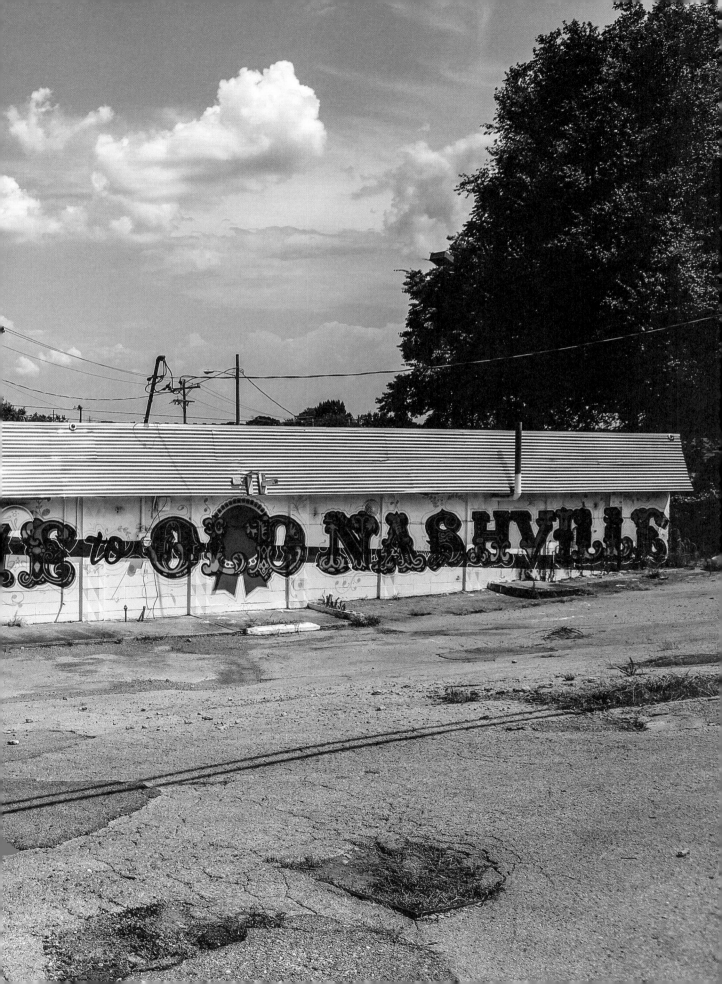

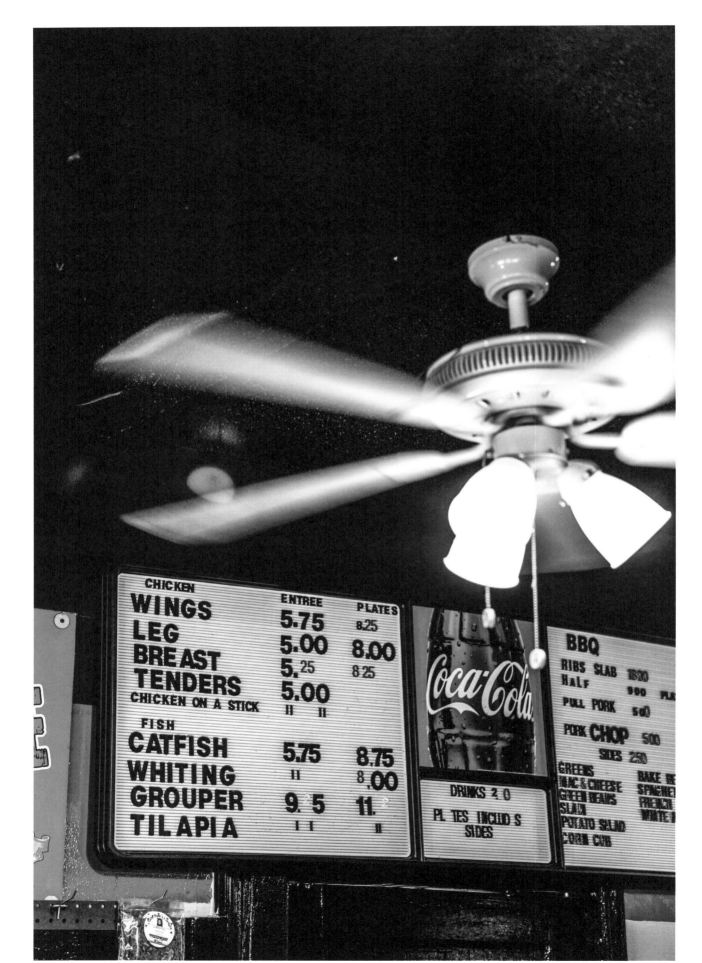

CONTENTS

CAST (IN ORDER OF APPEARANCE)

Aaron Turner
author, hot chicken obsessive, proprietor of
The Hot Chicken Project

Colonel Harland Sanders (deceased)
businessman, KFC founder

Thornton Prince (deceased)
crown prince of hot chicken, Prince's founder

Bolton Polk (deceased)
head chef at Prince's, later owner of Columbo's

Claudia Sanders (deceased)
wife of Colonel Sanders

Mrs Childress (deceased)
member of staff at Colonel Sanders' gas station

Brother Z
Nashville-based chicken slinger

André Prince
great-niece of Thornton Prince, proprietor of Prince's
Hot Chicken, reigning queen of hot chicken

Girlfriend X
unnamed girlfriend of Thornton Prince, possible inventor
of hot chicken

Isaac Beard
proprietor of Pepperfire, hot chicken obsessive

Bolton Matthews
nephew of Bolton Polk, co-proprietor of Bolton's Spicy
Chicken And Fish

Jack Massey (deceased)
venture capitalist and entrepreneur, co-purchaser of KFC

John Y. Brown Jr
lawyer and co-purchaser of KFC, later politician and
55th Governor of Kentucky

The Idle Hour—Any Given Day

"Millers are two bucks, why go home?"

A Love Letter, of Sorts

You know, I've never really thought about it much, not until just now, sitting here with you guys drunk in this double-wide masquerading as a bar, just up the hill outside the glow of the neon-lit hell that Broadway has become. It must be strange seeing this for the first time in a while. Nashville and all of her changes.

It's probably the beer that's got us here—half-a-dozen too many, I'd say. The hours filled with endless bottles of High Life and Tennessee-sized shots of Four Roses, the mindless chitchat with the regular drinkers about the songs they wrote, the weather and the politics of a changing Nashville skyline, all the while accompanied by those country songs spilling distorted from the jukebox that for the last decade has sat in the corner, acting as bandaids for people like us, barflies slouched drunk at the bar. It won't be long before this bar is gone, like much of all old Nashville, disappearing almost overnight as development takes hold. The wall of death pasted in the bathroom a sobering reminder that all things change, all things come to an end.

But I am happy being here with you all in this holy temple of late-night confessions. The karaoke drunks have long since gone home and now it's just the three of you, along with me and that doppelgänger of the high priest of country, Willie Nelson, tending bar, smoking cigarettes and reading his copy of *Gun and Garden*.

I've always said a bar is better than any therapist's couch. No truer words spoken the world over than at 1 am in a bar. Cheaper, too.

And I guess we've a lot to talk about, the four of us. Harland Sanders, I know you need no introduction. The Colonel king of southern fried chicken, fabled with an anger a mile wide, built from a life soothing wounds cut deep from both years of failure and those of roaring success, or so they say. You're a hard man to find any truth in and why you're even here, well, I'll get to that.

Thornton Prince, the ladies' man and undisputed crown prince of Nashville's chicken and city folklore, the flag-bearer for all that's come and all that will, the holy reason I'm sitting here today. And then there's you, Bolton Polk, the quiet, unsung hero of the hot bird.

I've been tasked with writing on the now famous bird, a mission undertaken with reckless abandon, ingesting all that the Music City has to offer. The searing heat, blurry nights lost in backdoor honky-tonks, rooftops and dive bars, days of eating fire-ladened chicken washed down with cold beer, cocktails at 308 and shots of Tennessee whiskey can take their toll, though.

It scatters the brain.

I lived here once, you know. Right behind all those shiny new skyscrapers. You used to be able to see it from here, the Stahlman. That's a while ago now, in another life.

I've been back now for seven days, on a hot chicken bender of sorts. At last count scribbled on the back of red- and orange-stained napkins there's been:

287 beers drunk, not accounting for the lost, discarded or spilled
184 chicken wings, dismantled and cleaned down to the bone
12 pieces of dark meat, bone-in leg and thigh, all fiery red and hot as hell
10 pieces of white meat, bone-in, of course (I mean no disrespect)
8 hot chicken sandwiches
3 catfish sandwiches
1 Duke's and ripe-as-hell tomato sandwich (I couldn't resist, those southern-ripened tomatoes will ruin you for all others).

There's also been:

36 cups of coffee, for waking and sobering up
4 hangovers (at last count)
1 gallon of unsweetened ice tea
1 bus
4 flights
2 delayed flights
30 hours in an airport lounge refugee camp
78 hours of travel
6 Temazepam
1 blackout
1 handful of non-descript yellow uppers
33,904 kilometres travelled.

All of which makes for one bloated, happy carcass.

There you have it, my hot chicken tour of the South.

It's a love letter, of sorts, to the three of you and to the city that changed the course of my life. Thornton and Bolton, the chicken, your chicken—that chicken that leaves you breathless, sweaty and so happy: what you created was something so uniquely Nashville that, while now copied the world over, is never quite the same as it is right here, in its spiritual home.

I've lost count of the hours, though judging by the empty bottles it's been a while.

But I've nowhere else to be and I imagine y'all are caught somewhere between the past and now, drinking in this bar with me.

So let me tell you the story of where this love letter begins. But before I start, I think there's something on which we can all agree.

Hot chicken ain't nothing but the truth.

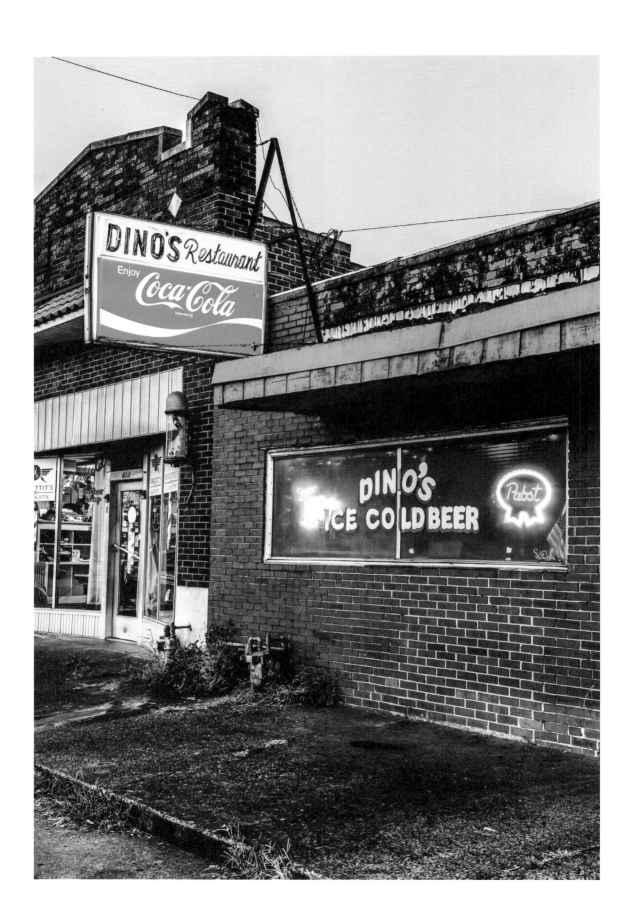

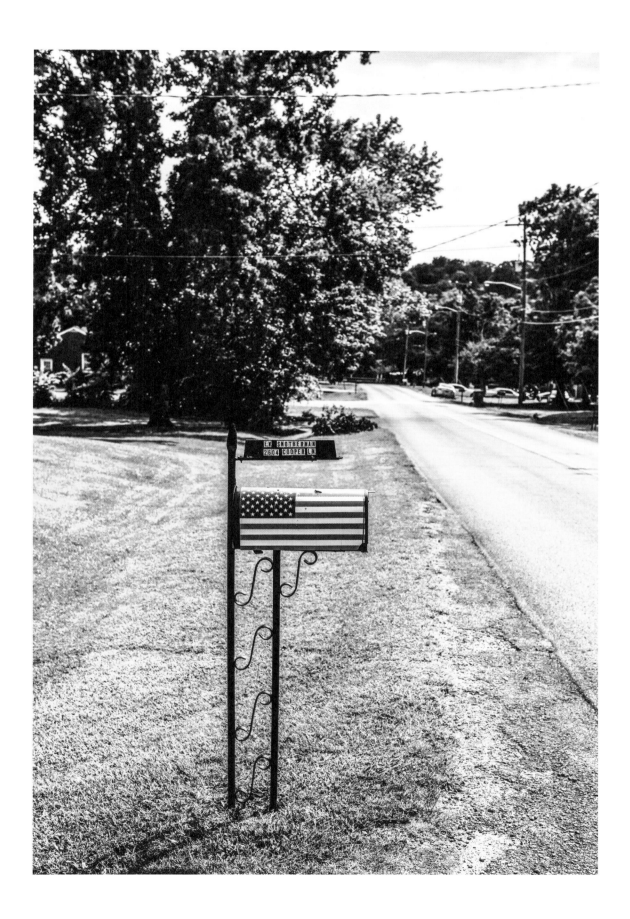

LOUISVILLE

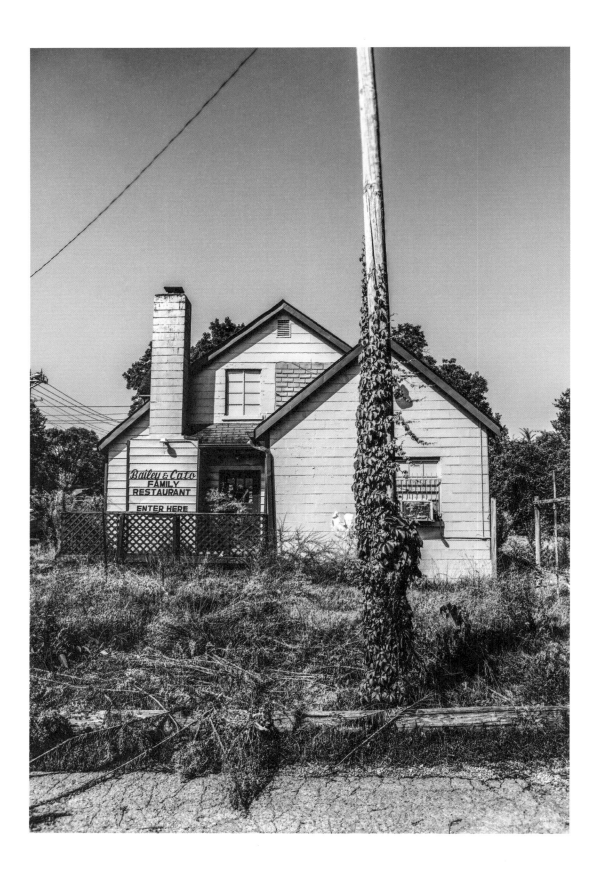

I have a confession to make, so perhaps I should start with that—let you all know the truth.

You see, I have this love of fried chicken that borders on obsession. That moment when a perfectly fried joint of bird has that crunch and is seasoned just right, the herbs and spices so perfectly balanced. It leaves me spellbound. It transports me— a moment of happiness in an otherwise maddening pursuit of perfecting my craft. That feeling you get when you cook a piece just so, spending the time preparing everything just perfect, the spices tried and tested, each gram measured and freshly ground, the flour sifted and sifted again, making it as light as possible before folding through the spices, never rushing. Taking the time to bread each piece so evenly and perfectly, taking extra care to press the mix into every nook and cranny, letting them sit in between the process to soak up the breading.

There was a hack I was taught once on a road trip through Kentucky. I was eating a piece of southern fried in a shack hidden off a side road down a dusty old backstreet in a neighbourhood I probably shouldn't have been in. It was so perfect in temperature from bone to crust I was compelled to ask how it was done in a kitchen that consisted of an ancient two-burner stove and a cast-iron skillet that looked older than me.

"Honey, it's simple. You gotta have that chicken outta the fridge at least two hours before the fry, otherwise your chicken gonna be no good."

Then there's that sound, that moment you drop a piece of chicken ready to fry into a bubbling and sizzling skillet. That moment of joy when all is well with the cook, being careful to keep an eye to adjust the temperature as needed, making sure those bubbles of lard stay the same size—a sure sign your fats are at the right temperature. That rhythmic sound of the spoon against the side of the skillet as you baste the chicken is music to your ears, carefully counting each

time the hot lard is spooned over each piece—always basting, always watching until the joints turn perfectly golden, forming an armour around each piece and allowing them to gently steam underneath the golden crust.

I won't bore you with the details of what exactly that can do to a man obsessed with flour, spice, oil, lard and chicken. Just know it's a thing of beauty that can't be rushed.

And this is partly why I'm here, to understand it all. The obsession, the love, the intrigue a fried piece of bird holds for folks like me.

CAVE HILL CEMETERY–THE GOLDEN HOUR

There's a humid breeze here at the gravestone that, even when gently winding its way through the magnolias, offers little relief.

I gotta say, it's too early to be this hot.

It's on days like this I picture Colonel Harland Sanders sitting on his porch, bourbon in one hand, cigar in the other, rocking back and forth in his wooden-framed chair while Claudia potters in the kitchen, tweaking and perfecting that now famous recipe with all the fixin's for dinner. There he is, gently swaying backwards and forwards, quietly content with how it all ended up, with how he played the game and the eventual fame and fortune it afforded him.

Then I wonder if it did, and maybe I have it all wrong. By all reports it was a crazy ride—moments of failure and madness, shootouts, lawsuits and fights, years of ferocious unhappiness because he felt that, in those moments of defeat and rejection, he was failing in his life's pursuits.

I know he suffered rejection of his now famous recipe 1009 times before someone believed in him. One thousand and nine times until someone saw what he saw, the potential of his chicken, those eleven herbs and spices that he spent hours

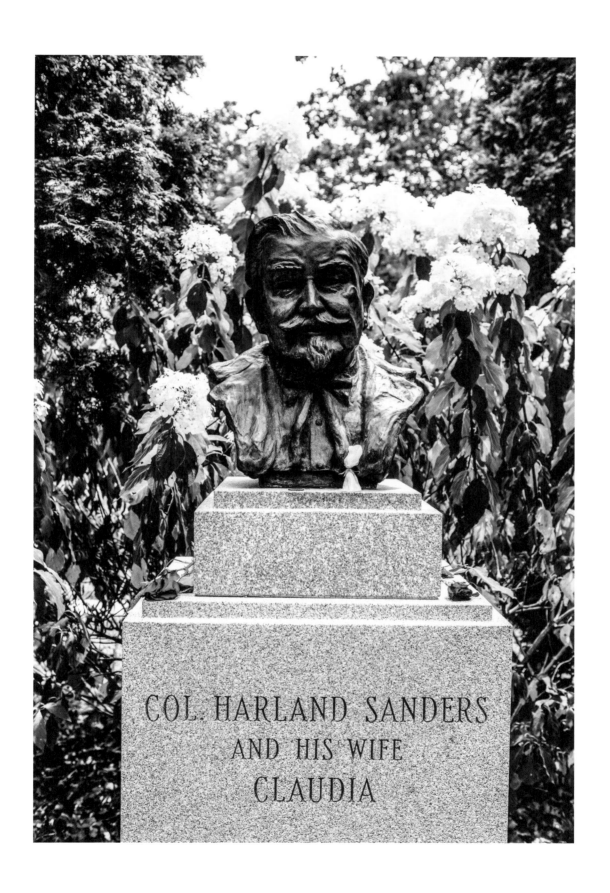

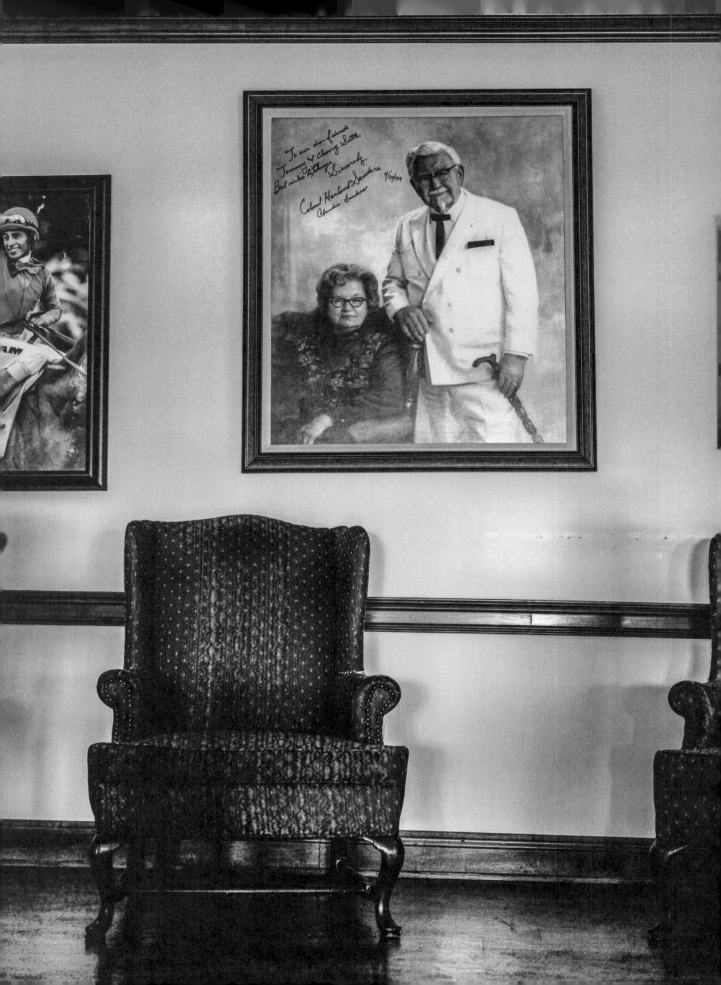

upon hours toiling over and perfecting in that gas station kitchen on that dust-worn stretch of road through Hell's Half Acre in Corbin, Kentucky. It was 1009 times before he could convince anyone to fall as hopelessly in love with that chicken as he was.

You see, the Colonel and I have spent the better part of our lives chasing the perfect chicken fry. For me, it started all those years ago when he came to open in my town, hooked on what lay behind the secrecy of it all. Even before I knew I wanted to be a cook, before I ever picked up a knife to become a chef, I was obsessive about figuring it all out. I once flew to the other side of the world, took two trains, a bus and walked six blocks in a pair of worn-out Converse in the middle of a snowstorm through the suburbs of Chicago to eat what was claimed to be the city's "Best Fried Chicken" only to find out the place was nothing but a dirty old building behind a laundromat serving boneless pieces of soggy fried and hot dogs under warming lamps. I ended up with nothing but numb feet, a tasteless meal and a head cold.

For the Colonel it began at seven years old, learning the craft, cooking with his mother. At first perfecting the bread, then the vegetables, foraging in the fields for sassafras buds and May apples, being left to cook for his siblings and to survive for days on his own while his mother was away peeling tomatoes in the canning factory, leaving him armed with enough knowledge not to burn the house down.

I can tell you're confused—I don't blame you and, trust me, I wouldn't be standing here in this graveyard talking if I didn't sense a spiritual connection. I'm a long way from home.

You see, the Colonel and I share this connection, this maddening belief that there is a perfect piece of fried chicken.

I should elaborate.

I grew up in the middle of nowhere. A port town, small plot of sand and rocks cut off from the world by a savage black coastline. A town with a factory, a supermarket and a video store. A small town made famous by two things: the brutal daylight murder of two hairdressers and the day the royals came to visit.

My upbringing wasn't anything like his—running away to join the army at sixteen in the hopes of enlisting and fighting the war being fought in far-off lands. For me, at sixteen, it was skating the abandoned gas station, listening to Dead Kennedys records and being angry with the world. I wore a thick metal chain around my neck, hair spiked bright blue, nose pierced, my days spent writing three-chord punk songs on a broken guitar, screaming lyrics about my distaste for the world and all authority in it.

Strange, I know, to be telling you all this, but I have a point and I'll get to it.

It was sometime in the dead of winter that construction started, an announcement in the local paper that the Colonel was coming—Kentucky Fried Chicken was opening in our town.

At first it was just a wire fence, a seemingly futile barricade to keep the curious eyes at bay. For months and months it lay bare, nothing but a pile of broken-up rocks and holes that filled with water from the weeks of endless rain.

For the months it took to turn the rubble into one of his shiny new restaurants I would ride my silver BMX through the sea mist that hung low under greying coastal skies always heavy with rain. It was no deterrent—I wasn't scared of a little rain. I needed to know what was happening beyond that wire fence, why the allure of the spinning bucket was so strong. For some reason it just seemed so magical.

I felt the world was finally coming to my small town.

A few friends took jobs there, bragging down by the gas station that they would soon be able to get as much free fried chicken as they could possibly eat, and that they would know the secret combination of eleven herbs and spices that would be brought to our town. A girl from my class had promised that, as soon as she had completed the training, she would share with me the recipe and I too would be in the inner circle of knowledge—anointed as one of the keepers of the secret.

Sadly, as I was to learn, she couldn't make good on that promise and later told me that the chicken came packed, frozen and ready to fry. I couldn't believe it but it was the first of many disappointments to come.

All this was long before I was an apprentice cook working my way through kitchens, doing all the usual things apprentices do—scrubbing floors, dicing vegetables, cutting fingers, cleaning walk-ins and getting screamed at for the better part of fourteen hours a day.

All before I was to learn the virtues of a bird that had been properly prepared, before I discovered what a good piece of fried chicken could do for the soul.

I want to show you something. I'm taking a trip, heading south to Nashville—a revisit of sorts, an unfinished love story.

I need to know if it's still there, that love and obsession that led my life in such a different direction. Something that changed the direction of not only my life, but, in some ways, the fortunes of this sleepy southern city.

I've been away too long and feel compelled to return, to pay my respects to the makers, the cooks, the workers and families. To make sure what I do back home is doing all of this justice.

But before I go on, I gotta ask, and I've wondered about this for some time, is now a good time to talk about Mrs Childress? Was it hers, the recipe? The secret eleven herbs and spices. Were they stolen?

I can't quite shake the feeling they were. But perhaps that's a conversation best saved for later.

There's a gas station on the outskirts of town. It's one of those neon-lit twenty-eight-bowser hellholes selling little but keychains, cigarettes and lukewarm beer—a stop on the interstate for the tired and overworked drivers.

It sells fried chicken, of sorts—a brand of golden chicken franchised to places like this. It's the model the Colonel set out to achieve all those years ago, when he crisscrossed the country armed with his secret herbs and spices, cooking it for people in the hopes they would agree to sell it at their gas stations and restaurants all over America, taking a nickel in turn for every joint sold.

I used to be able to convince myself after a few too many of those lukewarm beers that it was good. I would, half-drunk, even spruik its deliciousness to anyone who would listen, taking the occasional detour to indulge in a piece or two. I guess if you've been on the road long enough you can convince yourself of anything, really.

HENDERSONVILLE

You'd drive right past it if you didn't know—if you weren't given the inside scoop. We've been on the road for long enough and I'm guessing we're in need of some chicken. It's a one-man show out here, everything made by the hand of this East Nashville native who found his way into the life of slingin' yardbird, serving down-south southern fried in a strip mall off Walton Ferry Road.

His chicken is some of the best in the business. He's a cook's cook—a believer that it all starts with the base, the spices and the flour, and if you ain't fucking with that you stand a chance of cooking some good chicken. A believer that there ain't nothing truer than word of mouth to spread the gospel of what he is doing out here.

I promise that his cuts speak for themselves—a piece of southern fried with proper mac 'n' cheese and braised green beans cooked long and slow will have you transcending. The wings—mildly spiced—things of beauty, and, with slaw and hickory-smoked baked beans, the perfect antidote to a long drive.

It's just a quick stop here before we hit Nashville, where our story really begins.

David Moore of Moore's Spicy Fried Chicken, Hendersonville TN

GAS STATION FRIED CHICKEN

When breaking down your chicken here, separate the dark meat into legs and thighs and cut the white meat in two, leaving the wings and the breast plate attached. The crust coating the chicken should be soft with just a little crunch and the chicken warm or at room temperature when serving.

Serves 4–6

250 g (9 oz/¾ cup) rock salt
2.5 litres (85 fl oz/10 cups) warm water
1 × 1.2 kg (2 lb 10 oz) chicken, broken down into 8 parts
500 ml (17 fl oz/2 cups) cottonseed or grapeseed oil
400 ml (13½ fl oz/1⅔ cups) canola oil

Coating
300 g (10½ oz/2 cups) plain (all-purpose) flour
125 g (4½ 1 cup) cornmeal polenta
1 tablespoon table salt
1 tablespoon celery salt
2 tablespoons ground black pepper
2 tablespoons dried oregano

Add the rock salt to the water in a large bowl and stir to dissolve. Lower the chicken pieces into the brine and leave for 3 hours.

Meanwhile, for the coating, mix together all the ingredients in a large bowl.

Remove the chicken pieces from the brine and transfer to a suitable container, pour over the coating mixture and push down to pack tightly, covering the surface of the chicken. Cover and leave in the fridge overnight.

The next day, remove the chicken from the fridge and leave for 2 hours to come to room temperature.

Preheat the oven to 100°C (210°F).

Heat the cottonseed and canola oils in a large heavy-based skillet or saucepan to 180°C (350°F).

Gently lower the chicken pieces into the hot oil, maintaining the temperature as best you can, and fry until a golden crust starts to form around the chicken pieces, about 6 minutes. (At this stage the chicken won't be cooked through.)

Remove from the hot oil, transfer to an oven tray and bake in the oven for 40 minutes, or until the chicken is cooked through. Season and leave to sit on the bench for 20 minutes before serving.

BRAISED GREENS

You might assume that cooking greens for hours like this would turn them to mush but, by some miracle, these stay intact and still have a great texture. I assume Heston could explain this but, really, who cares? I don't want to know the magic—I prefer to stay in wonder and just know these are delicious.

If you're using collard greens here, be sure to give them a good wash before removing the stalk by folding the leaves in half and ripping down the centre. Cook for at least an hour—or longer if needs be—until tender, and add a sprinkle of sugar if they taste a little bitter.

Serves 4–6 as a side

1 tablespoon lard or olive oil
1 brown onion, finely sliced
1 × 400 g (14 oz) smoked pork hock
2 litres (68 fl oz/8 cups) water
375 ml (12½ fl oz/1½ cups) cheap beer
1 teaspoon salt flakes
1 chicken stock cube
600 g (1 lb 5 oz) mustard leaves, turnip greens
 or collard greens, washed
white pepper

Warm the lard or oil in a heavy-based saucepan over a low–medium heat, add the onion and sauté until soft, about 4 minutes.

Add the smoked hock to the pan and cook, turning regularly to avoid burning, for a further 5 minutes or until coloured on all sides.

Combine the water, beer, salt and stock cube in a bowl, then pour the mixture into the pan and bring to the boil. Add the mustard leaves, reduce the heat to a very gentle almost-simmer and leave to cook for 1 hour, or until the meat from the hock is falling off the bone and the greens are tender. Season with salt and white pepper to taste, then serve.

FRIED GREEN TOMATOES

Though it's tempting to dive right in after making these, be warned—they really hold their heat. So, unless you fancy sustaining third-degree burns to your mouth, have a beer, a chat and a chill out before you get started. And, yes, these are also great sprinkled with smoked paprika or cracked pepper, drizzled with honey or coated with hot sauce, but my preferred option is to smother the lot in Ranch (see page 81).

Serves 4–6 as a side

300 ml (10 fl oz) apple-cider vinegar
1 tablespoon hot olive oil or melted lard, plus extra
 for deep-frying
pinch each of salt and pepper
6 medium green tomatoes, cut into 1 cm (½ in) thick slices
200 ml (7 fl oz) buttermilk
300 g (10½ oz/2 cups) cornmeal polenta

Combine the vinegar, olive oil or lard, salt and pepper in a large bowl. Add the tomato slices and set aside to pickle for 1½ hours.

Pour the buttermilk into a bowl. Add the polenta to a second bowl.

Once pickled, drain the tomato slices. Dip a tomato slice first into the buttermilk, then remove and shake off the excess before placing in the bowl with the polenta to coat all over. Transfer the coated slice to a tray and repeat with the remainder. Set aside in the fridge until needed (they will keep like this for up to 1 day before frying).

When ready to cook, half-fill a heavy-based skillet, saucepan or deep-fryer with oil or lard and heat to 180°C (350°F). Working in 2–3 batches, carefully lower in the tomato slices one by one and fry for 4 minutes, turning halfway through cooking. Drain on paper towel and season with salt before serving.

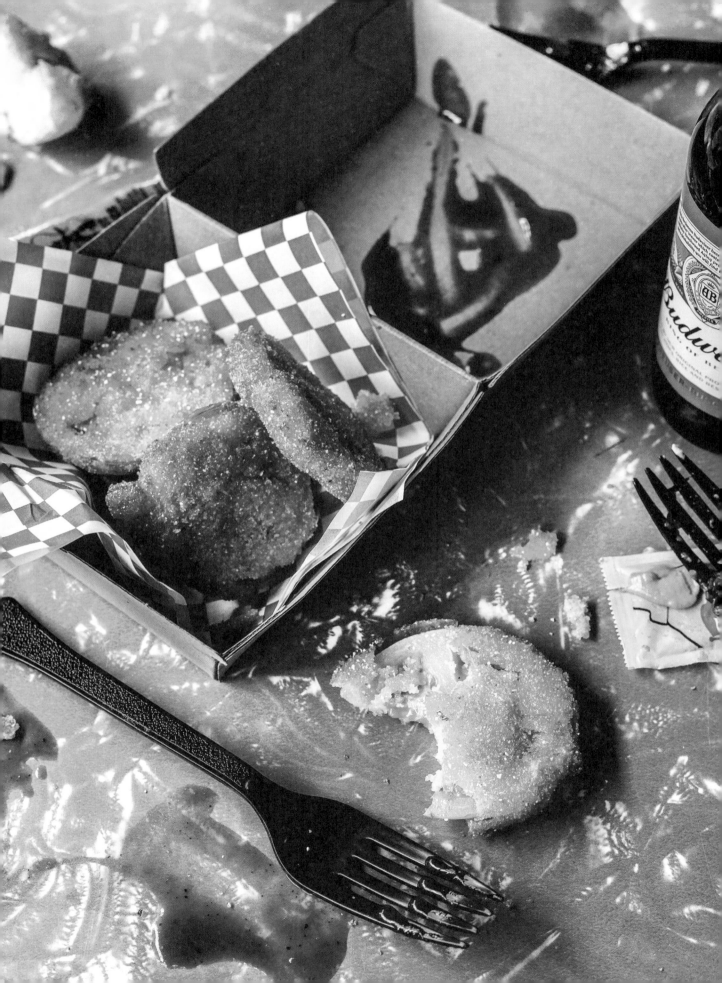

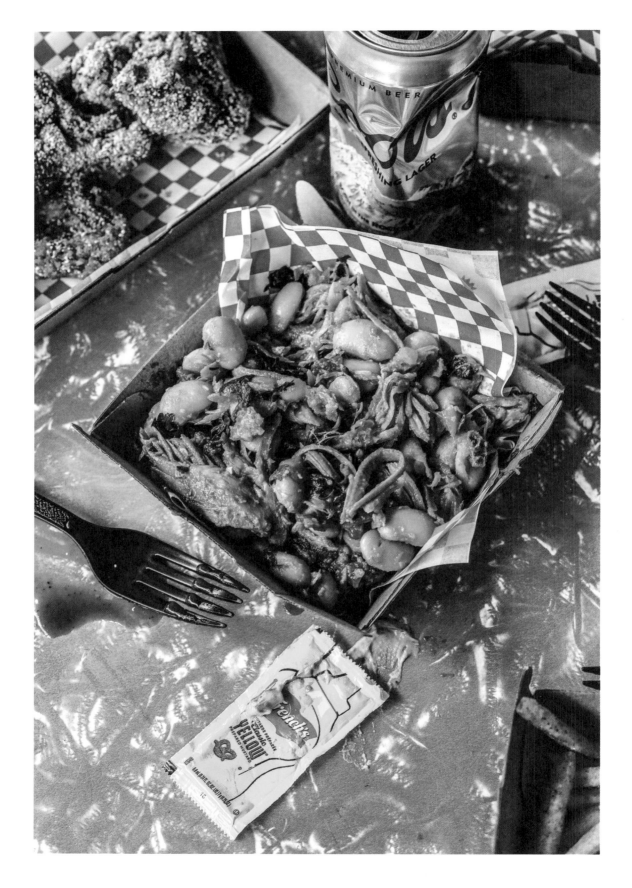

PORK + BEANS

A rich stew of two of my favourite things, braised smoked pork and preserved beans, this makes a hearty side or a meal all of its own.

Serves 4–6 as a side

100 ml (3½ fl oz) olive oil
1 onion, diced
1 × 400 g (14 oz) smoked pork hock
80 g (2¾ oz) tomato paste (concentrated purée)
250 ml (8½ fl oz/1 cup) chicken stock
50 ml (1¾ fl oz) worcestershire sauce
80 ml (2½ fl oz/⅓ cup) molasses or black treacle
1 tablespoon soft brown sugar
1 tablespoon dijon mustard
sea salt and white pepper
500 g (1 lb 2 oz) tinned navy (haricot) beans, drained
1 bunch of flat-leaf parsley, roughly chopped

Heat the olive oil in a cast-iron pot or heavy-based saucepan, add the onion and sauté over a low–medium heat for 5–6 minutes until translucent and soft. Add the pork hock, cover with a lid and cook for 30 minutes.

Meanwhile, whisk together the tomato paste and chicken stock in a bowl.

Add the worcestershire sauce, molasses, brown sugar and mustard to the pot. Stir in the tomato paste and chicken stock mixture, season well with salt and white pepper, cover and cook on a medium heat for 2 hours, or until the meat comes away from the bone easily.

Preheat the oven to 180°C (350°F).

Put the beans in an ovenproof dish. Spoon the pork mixture over the beans, transfer to the oven and cook, uncovered, for 30 minutes or until thickened and sticky. Stir through the parsley and season with salt and white pepper. Serve.

A BASIC BREADING RECIPE FOR A SIMPLE FRIED

I'm not going to give you my recipe. It's an almost-secret. Of course, lots of people who work at my place, The Hot Chicken Project, know it. And it's not like it's under lock and key, buried in the basement of an evil corporate headquarters—it's on a Google drive with a password. But it *is* something I've spent a lot of time (and miles eating hot chicken) working on to get to a place where I'm happy.

I will share this one, though, which still tastes amazing and can be used as a replacement coating for any of the fried chicken recipes in the book. But it won't be the same as when you eat at the restaurant.

Makes enough to coat 1 chicken

375 g (13 oz/2½ cups) plain (all-purpose) flour
125 g (4½ oz/1 cup) cornflour (cornstarch)
2 tablespoons smoked paprika
1 tablespoon white pepper
1 tablespoon table salt
1 tablespoon dried oregano
1 teaspoon garlic powder

Mix everything together in a large bowl, then pass the mix through a flour sieve or a fine-mesh strainer. That's it, you are ready to go—just keep it stored in an airtight container in either the fridge or the pantry until needed (it will keep for ages).

POTATO CAKES

Serves 4–6

6 waxy potatoes, cut lengthways into 2 cm (¾ in) thick slices
150 g (5½ oz/1 cup) Spiced Flour Mix (see page 189)
vegetable oil or lard, for deep-frying
sea salt and white pepper

Batter
550 ml (18½ fl oz) cheap beer
400 g (14 oz/2 ⅔ cups) plain (all-purpose) flour
1 tablespoon salt
2 teaspoons bicarbonate of soda (baking soda)
2 tablespoons vodka
½ teaspoon onion powder
½ teaspoon garlic powder

Put the potato slices in a large heavy-based saucepan and cover with cold water. Over a very low heat, bring the water to a gentle simmer and cook until a knife tip easily pierces the potato, about 25 minutes. Carefully remove the potato slices from the pan and leave to cool on a wire rack.

Meanwhile, make the batter by combining all the ingredients in a bowl and whisking together until smooth. Place the spiced flour in a bowl.

Once cool, dust the potato slices in the spiced flour and dip one by one into the batter.

Half-fill a large saucepan or a deep-fryer with vegetable oil or lard and heat to 185°C (365°F). Fry the slices until golden brown, about 3 minutes. Season well with salt and white pepper while still hot. Serve.

84A SAUCE

Yes, my love for hot chicken borders on the obsessive, but I don't *always* want it spicy and hot, and this is a great recipe to dip, smother or smear all over your southern fried without fear of fiery retribution. It's a sneaky take on a popular sauce. (I won't tell you which one, but let's just say it has numbers on the label and adds zest to chicken, steak and pork.)

Makes 1 litre (34 fl oz/4 cups)

600 g (1 lb 5 oz) tomato passata (puréed tomatoes)
2 tablespoons tomato paste (concentrated purée)
300 ml (10 fl oz) apple-cider vinegar
50 ml (1¾ fl oz) malt vinegar
200 g (7 oz) brown sugar
60 ml (2 fl oz/¼ cup) honey
100 g (3½ oz) dijon mustard
2 tablespoons worcestershire sauce
1 tablespoon onion powder
1 tablespoon garlic powder

In a blender, combine all the ingredients and blitz on medium for 3 minutes or until smooth, being careful not to heat the sauce.

Strain though a fine sieve and store in sterilised bottles or jars until needed (it will keep for ages).

NOTE: TO STERILISE BOTTLES AND LIDS, WASH THEM IN HOT SOAPY WATER, RINSE WELL, PLACE THEM ON A TRAY IN A COLD OVEN AND HEAT AT 120°C (365°F) FOR 30 MINUTES. FILL WITH YOUR SAUCE WHILE STILL HOT AND SEAL WITH LIDS, THEN SET ASIDE TO COOL.

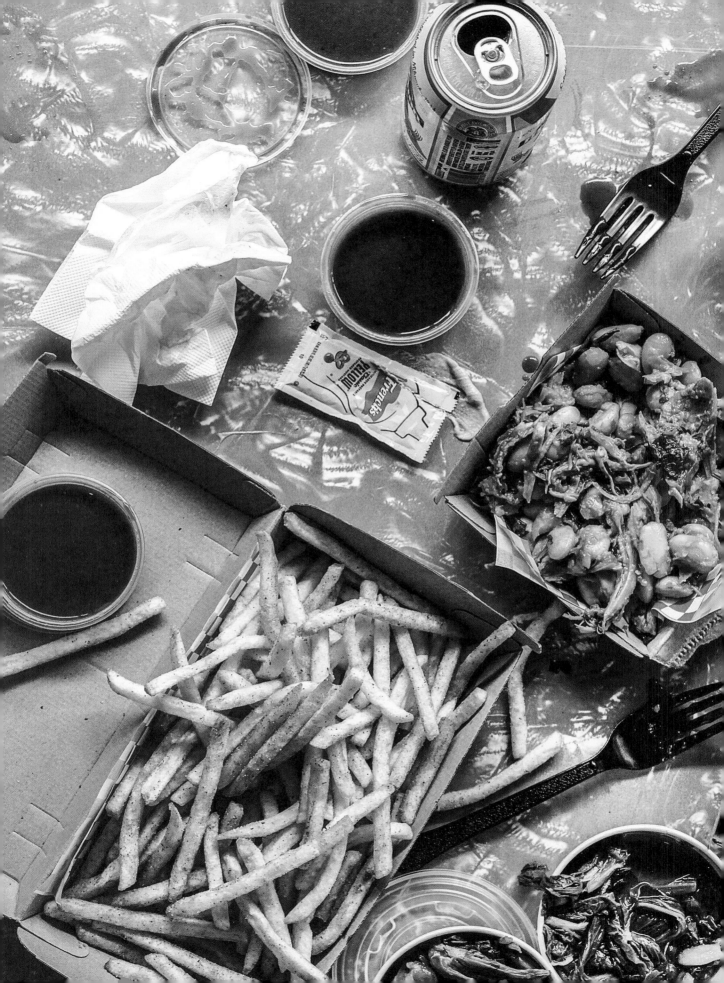

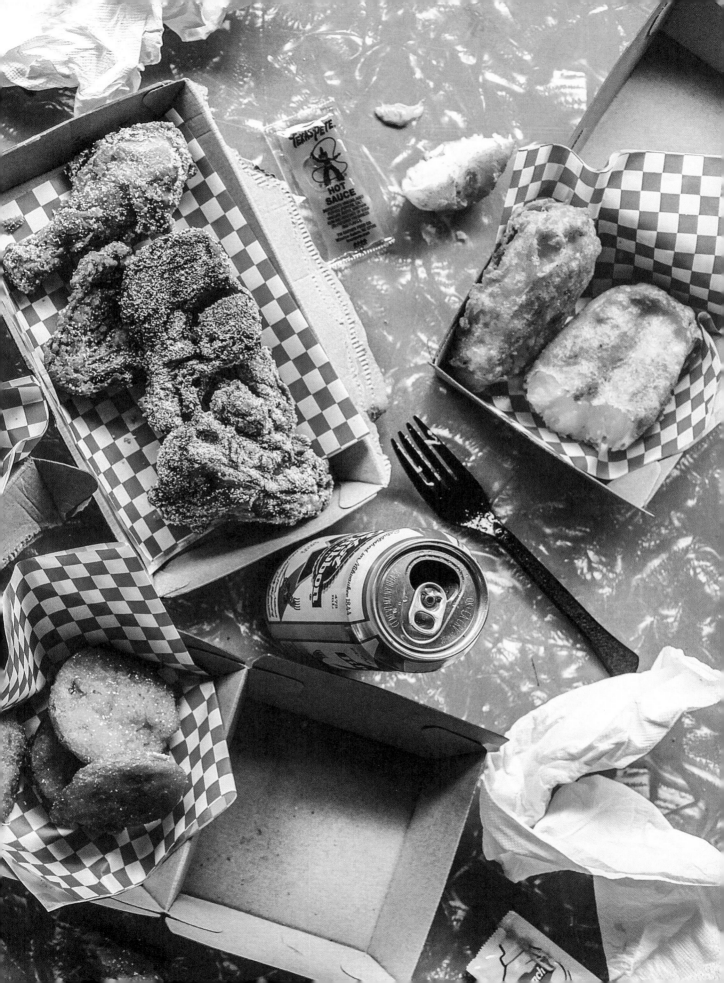

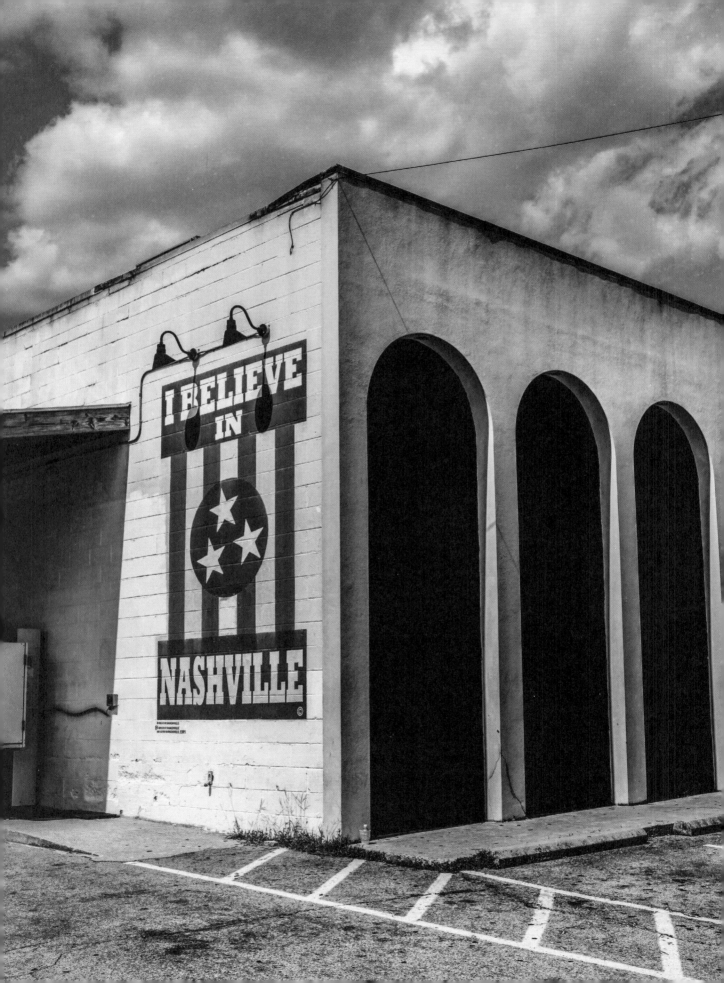

NASHVILLE

It's the drive east on Dickerson Pike that'll first get to you.
The neon of lower Broadway slowly fading in the rear-view
mirror, making way for more honest streets.

You'll notice the pavement is cracked and worn, windows
broken here and there, some houses burnt to charred frames.
Double-wides that have lasted a lifetime sit rotting and falling
down—the southern jungle, reclaiming its own.

It's not much further now, just a little past Brother Z's
Wang Shack.

Or where it used to be. It's closed now, and Brother Z sits
in the parking lot underneath his old, fading sign, watching the
traffic pass him by. He's found it hard to compete as the city
encroaches on his neighbourhood, new residents forcing the
rents up. His house burnt down recently and he's living in
the storage shed behind the restaurant now. Hoping that one
day, by the grace of God, he can reopen and start cooking his
wings again.

It could happen to any of us, what happened to Brother Z.
A city changing in the blink of an eye and the fortunes and
misfortunes that can bring.

Welcome to old Nashville—a painted reminder that this city isn't
what it used to be.

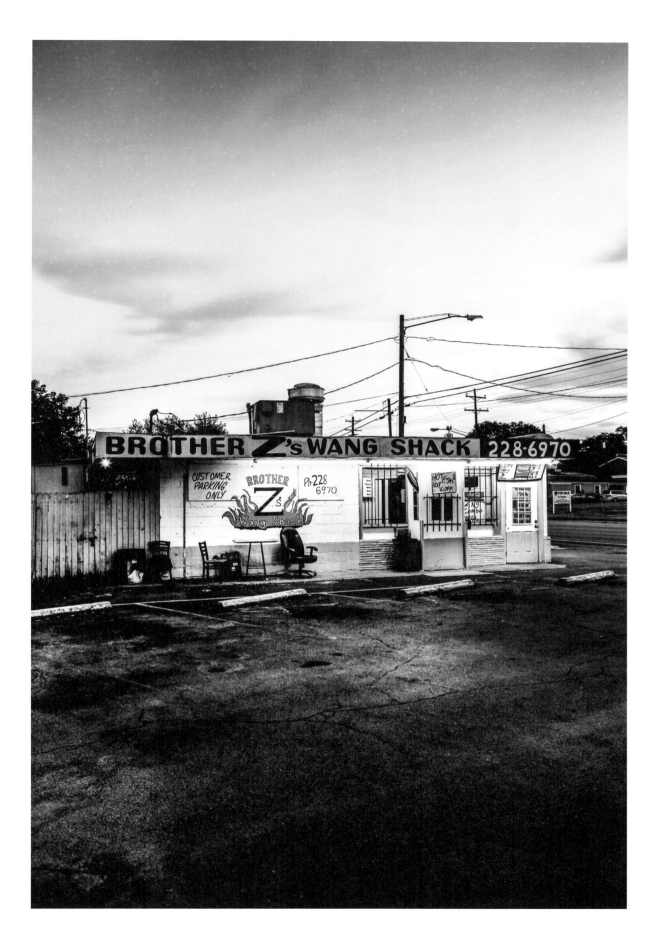

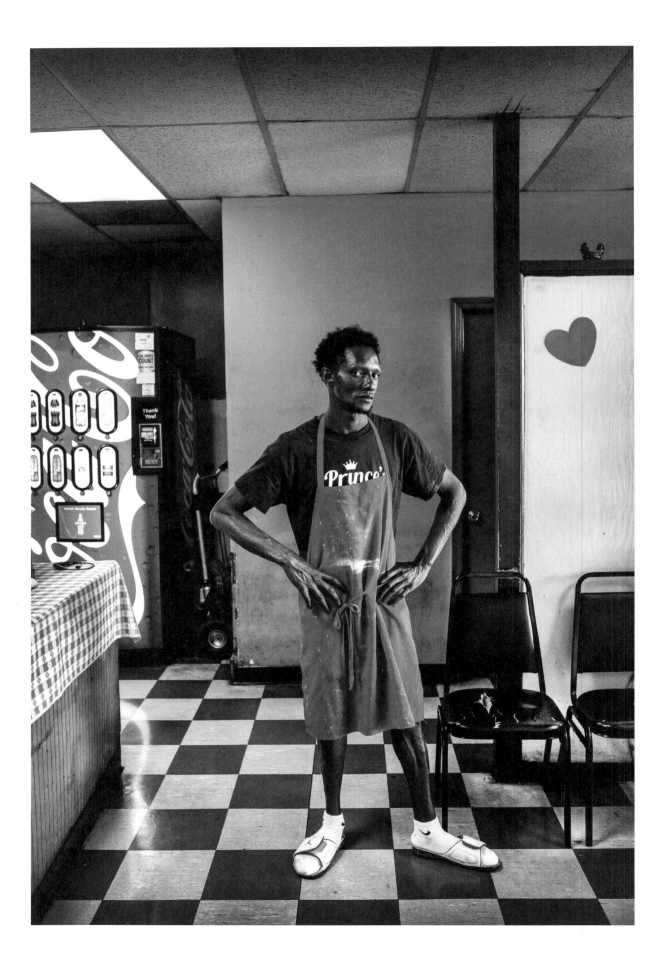

PRINCE'S HOT CHICKEN

TOLD THAT THIS
INFLUENTIAL BOOK
WAS TOO LONG,
HARRIET
BEECHER STOWE SAID
SHE DIDN'T WRITE IT,
IT WROTE ITSELF

Prince's
HOT CHICKEN

I've always loved the booths here—high-backed church pews, discoloured white and worn from years of use, torn vinyl tablecloths, stained with years of chicken grease. I never feel more at home than I do in places like this. They just feel *good*— words fail to do them justice. They seem wholesome and real.

The room is filled with families gathering for an early dinner, the kids tearing and chewing on wings, forgoing the plastic cutlery and preferring to eat with their hands (as one should). Digging into slaw and beans.

Couples sit smiling, quietly discussing what to order and what to share. Folks on their way home wait patiently for their favourite cuts to cook and get the Prince's treatment to go, happy to wait as long as it takes. They are all here for that perfect piece of fried chicken—that brown paper bag filled with salvation after a long day.

Fuck the million-dollar fit-outs. No money can create places like this. And you can't replicate the feeling you get from eating in places like this.

This place—Prince's Hot Chicken Shack—has been a part of Nashville for generations. The family Prince has been nourishing a community for longer than most of the restaurants that now fill the neighbourhoods and growing city skyline.

This place has been passed down through the family: generation after generation gatekeepers of the family secret after Thornton, the founder. First his brother Will ran the show until it was time to pass it on to his son, Bruce, whose wife, Maude, took over after he passed away—she steered the ship until it was time for their daughter, André, Thornton's great-niece, to take the reins. André, the reigning queen of Nashville Hot Chicken.

It's been a while now since I fell in love with this chicken, bathed and baptised in spices and fats, a dish that changed my course as both a cook and a person.

That's the power it has, this chicken.

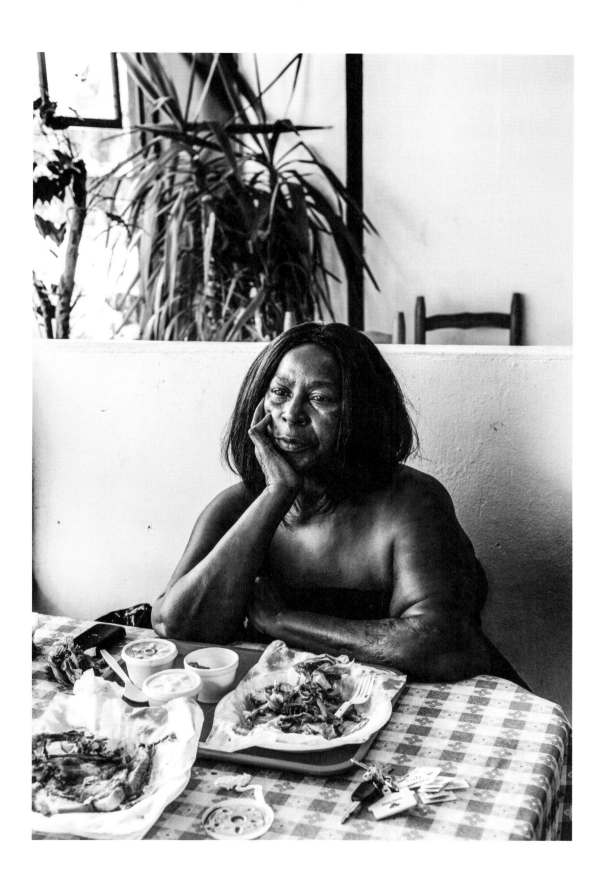

You want to know, right? How it all started?

The tale, now embedded deep in Nashville folklore, is that Thornton returned home late one evening after a night on the town drinking and gambling with the boys. Stumbling inside with the scent of another woman's perfume on his clothes, her lipstick on his collar, he claimed his innocence and still demanded an early-morning fixin' of his favourite skillet-fried chicken from his girlfriend. (Let's call her Girlfriend X. Her place in this story—this history—if true, is all but lost.)

I imagine this wasn't the first time Thornton had returned home under a cloud of suspicion.

Disgruntled by his behaviour, Girlfriend X decided to head out back and pick a handful of the cayenne peppers she had growing behind the house—heat-ripened from the southern sun— and, once she had fried up that chicken he loved so much to perfection, as she always did, in an act of revenge and in hopes of making his favourite meal inedible, she doused that chicken in a spice mix so hot it filled the air with an aroma formidable enough to wake him from his drunken slumber.

She was hoping against hope the chillies now coating the fried bird would ruin his favourite meal and teach him a lesson.

But, of course, it backfired. Sitting at his kitchen table, half awake, hungover, eyes still blurry from the night before, the first bite jolted him back to life. Fried chicken salvation. Thornton was revived—all the evils from the night before vanishing with each bite.

He loved it.

Hell, he didn't just love it, it drove him crazy. Thornton wanted more and more, he couldn't believe what he was eating—the fried chicken gods had delivered him a slice of heaven and he wanted, no, he *needed* more. It tasted so good, those spices, the heat—nose dripping, sweat beading, eyes watering from that heat. The crunch of the chicken, the burning of the chilli-laden fat. He fell instantly head over heels in love.

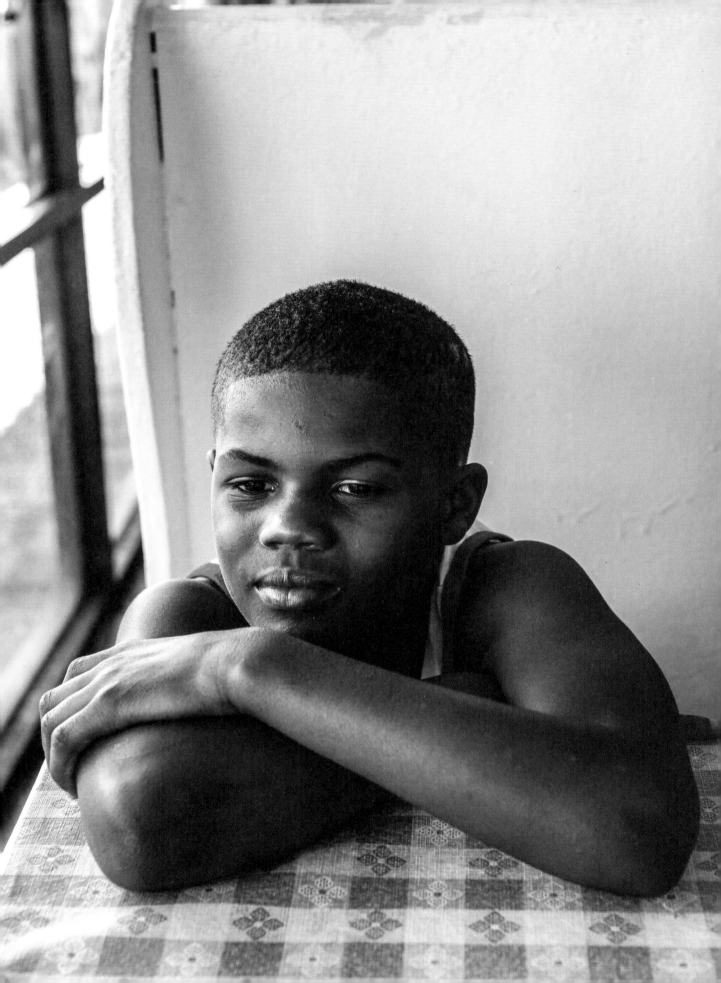

Thornton wanted more and more. He made her cook it again and again—every time he and the boys came home after a night out, he would demand she heat up the skillet and cook batches of her fiery bird, would sit there and watch as the whole table fell dizzy in love with what they were eating.

I wonder, is it true? Is Thornton's girl, the nameless Girlfriend X, the mother of hot chicken?

There's a common thread here, between the Colonel and Thornton and influential women, so perhaps now is a good time to talk about Mrs Childress. By all accounts she was a kind black woman who worked for the Colonel all those years ago at his gas station restaurant in Corbin, Kentucky.

Some say the recipe was hers. A well-known rumour in the community is that he took it and claimed it as his own and then, when her family started making noise about it, he silenced them with a $1200 cheque. An admission of guilt?

I gotta know, was it stolen? Are those now-famous eleven herbs and spices that are so shrouded in secrecy actually hers? Was it her recipe that people fell in love with the world over?

I'm just curious. Had neither Thornton nor the Colonel heard of the phrase "Hell hath no fury like a woman scorned"?

I remember my order from the last time I was here. It's been a few years now but, walking through these doors, it feels just like yesterday.

Give me two pieces of dark meat, leg and thigh, the best cut from the chicken if you ask me, well, right after the wing, of course. I'll get it hot—no one needs to be dealing with that triple-X burn first thing. It's been a while since I've been here and this is our first stop, so I'm dipping my toe in. I know what Thornton's chicken can do to a man—I've got the nervous sweats just thinking about it.

I'll also get a breast quarter—the white meat with wing attached. And a ranch and blue cheese. I'll take that piece plain, so I can taste all the spices that go into the flour mix before the whole thing gets drenched in those glorious fatty spices.

My mouth is watering already.

"Sides, Sir?"

I'll get fries, of course—those who know me know it's impossible for me to say no to fries—and let me get a potato salad. And baked beans. And a cup of pickles. Oh, and an unsweetened tea should do it. Wait, it's Wednesday, I know it's one of only three days that you serve wings, so let me get a double serve.

"How hot, Sir?"

Fuck it, I know I'll regret it but let's go XXXHot.

It feels so good being here again, watching the happy faces eating and laughing, hands stained red, sharing plates of food and making a mess on the green checker-topped tables. Makes me think it must have been something else when Thornton first opened Prince's in that shack downtown, by the mother church of country music, the Ryman Auditorium, home of the Grand Ole Opry.

Thornton and his brothers slingin' their chicken for the Nashville community.

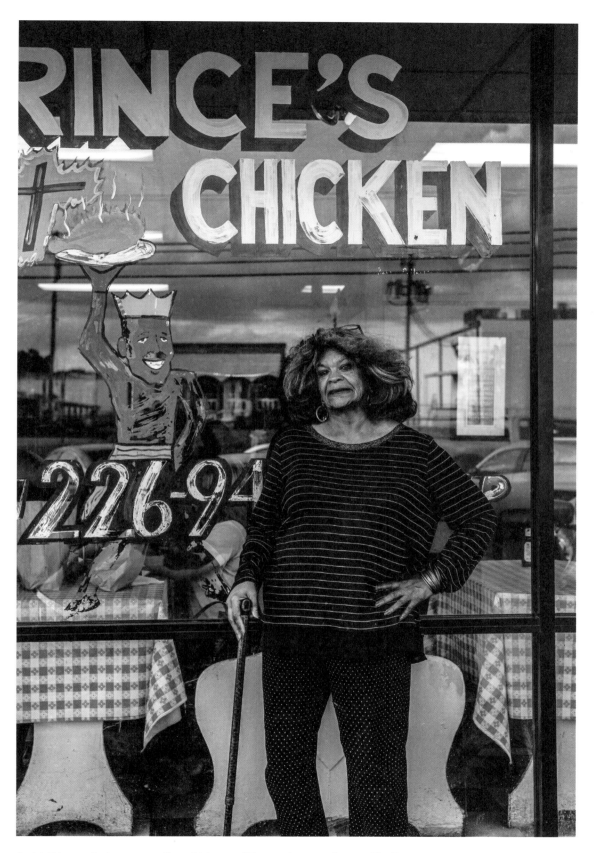

André Prince, reigning queen of hot chicken and Thornton's great-niece, at The Temple, 123 Ewing Drive, Nashville, TN

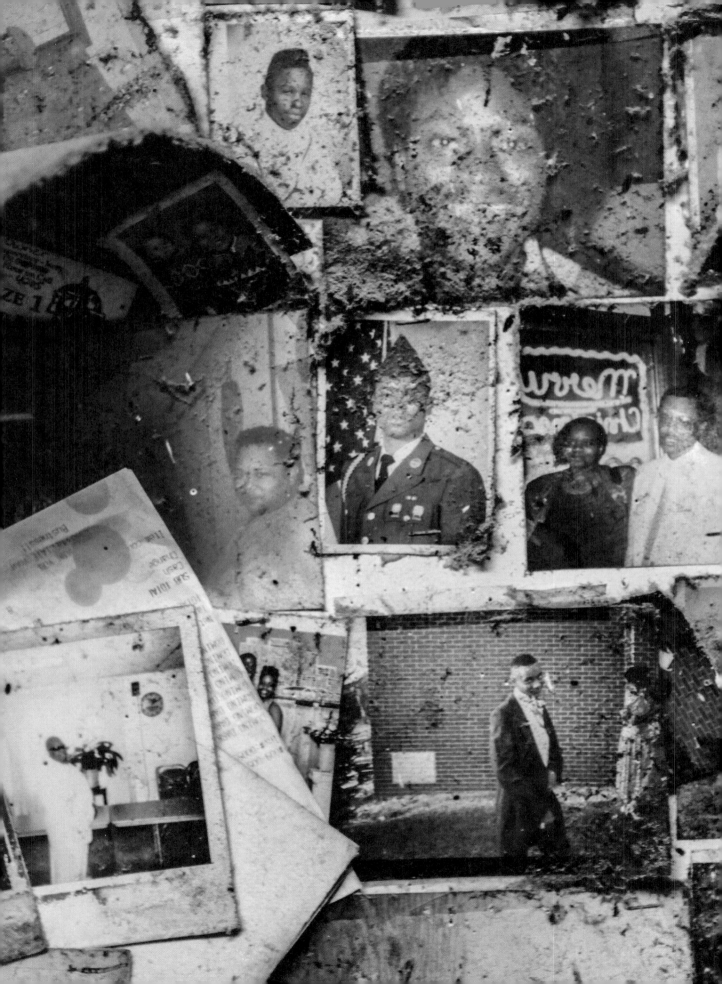

Story has it that after a day of toil on the farm, Thornton would collect his brothers from their shift at the post office and head to the restaurant on Jefferson and 28th, staying open till four in the morning cooking for the late-night crowd—a tradition kept today. A few hours of sleep and he'd be back at it again the next day. It was both a love for the chicken and a way to try to get the bills paid.

When the time came to move the shack, Thornton decided to move right to the heart of the action and into Hell's Half Acre, just a few blocks from the Ryman. The smell of his chicken would drive the performers at the Opry wild. One in particular, George Morgan, was so infatuated that in between performances he and his band set off on foot to find the source of that heavenly scent. Once they found it, they ordered their choice of cuts and, like everyone else, fell head over heels in love. It didn't take long before Prince's was flooded with a now-famous white clientele.

With the attention the country stars brought, and the complications of Jim Crow laws, Thornton had a problem. But not to be outdone, not to give in, and for the sake of everybody needing his chicken, he built a room out back and continued to operate Prince's like a white establishment only in reverse—blacks ordered and sat in front, whites out back.

I'm gonna tackle this dark meat now. It's been sitting here a good twenty minutes, yet when I stick it, steam still comes out—meaning it's still hot. That's a sure indication of a cook who knows what he's doing out back with the skillets and fryers, getting that perfect crust and seal of flour around the meat, locking the heat in tight.

◀ Photo wall of the Prince family

I'll tell you true: this chicken is straight-up hot and not to be trifled with. If I didn't know better, I'd swear it was blistering my lips.

My eyes are looking a little bloodshot and my face is starting to get a little sweaty. Now I'm panting like a rabid dog, desperate to cool my mouth. The water and iced tea offer no relief, the pickles useless in calming the burn. Maybe I should have eased in? But now I've started, I'm hooked, and no matter the damage being done—no matter the moments of regret I'll have at 2 am when my stomach is cramped and churning—I won't stop. I *can't* stop. It's just that damned good.

And it's not all fire and brimstone here. There's good cooking at play too. The chicken is nurtured from start to finish and I've never had a bad joint here. It's always spot-on, no matter the time it takes to do it.

Prince's is a church of fried chicken sandwiched between a nail salon and a discount smokes store. A strip mall community of drug dealers and pimps, musicians and workadays line the kerb, all coming together for a sermon at Prince's, with Thornton's great-niece André, the queen, holding preachment over the hot chicken addicts, first-timers and regulars.

The chicken holds a power all of its own here at Prince's—its spiritual home.

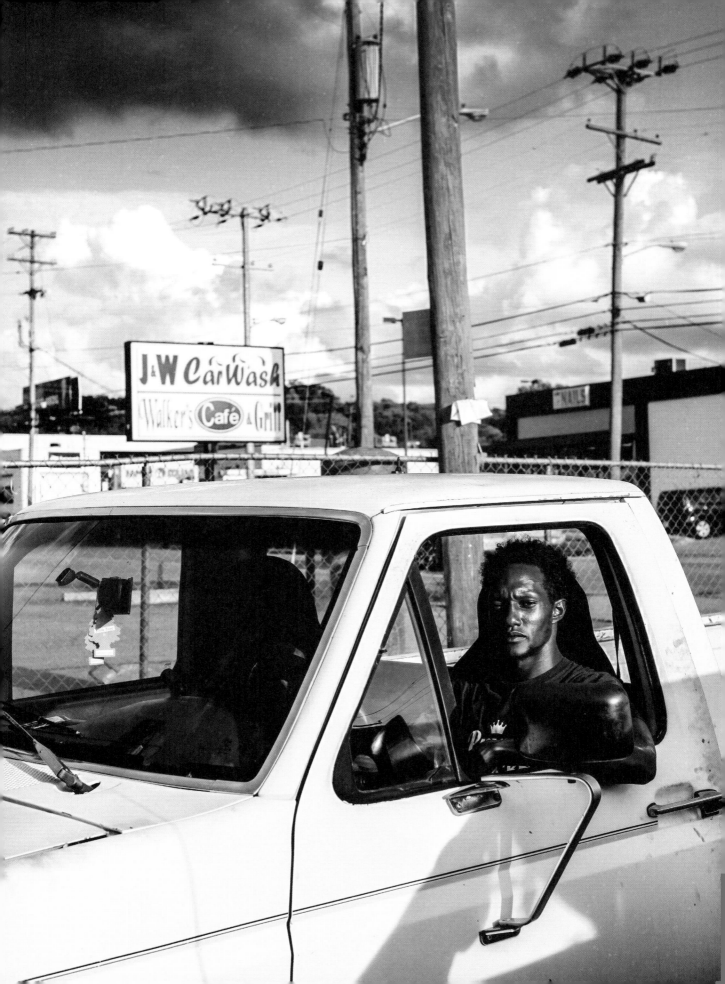

SKILLET-FRIED CHICKEN

This recipe is cobbled together from countless hours of trial and error and lots and lots of burnt chicken pieces, and if there's only one thing you take from it then make it this: don't skimp on the lard here. If you do, your chicken will be dry and nasty. One more piece of advice: don't cop out on the skillet. Invest in quality, take care of it and you'll be frying for a lifetime. (A splatter screen is also pretty much a chicken fryer's must-have—it'll save both your kitchen and your favourite metal-band t-shirts from ruin.)

Finally, when breaking down the chicken, be sure that the bones are left in and the skin is left on. There is no place in this world for skinless, boneless skillet-fried chicken.

Serves 4–6

1 × 1.2 kg (2 lb 10 oz) chicken, cut into 8 pieces (2 × wings, 2 × drumsticks, 2 × thighs, 2 × breasts)
500 ml (17 fl oz/2 cups) buttermilk
lard, for deep-frying
sea salt

Breading
600 g (1 lb 5 oz/4 cups) plain (all-purpose) flour
2 tablespoons cornflour (cornstarch)
1 tablespoon table salt
1 tablespoon smoked paprika
1 tablespoon ground black pepper
1 tablespoon dried oregano

Place all the chicken pieces in a bowl, pour over the buttermilk and toss to coat all over. Leave the chicken to sit for 20 minutes, then transfer to a wire rack set above a tray to let the excess buttermilk drip away.

Mix together the breading ingredients in a large bowl.

Individually coat all the chicken pieces in the breading mix, then transfer to a tray. Refrigerate overnight.

The next day, coat the chicken a second time in the breading mix and leave to sit at room temperature on a wire rack for 30 minutes.

Half-fill a heavy-based skillet with melted lard and heat to 180°C (350°F). Carefully add the leg and thigh pieces to the hot fat and cook for 4 minutes, then add the breasts and wings and cook for a further 4 minutes. Turn the pieces and continue to fry, turning as you go, until the internal temperature reaches 75°C (165°F) when measured with a probe thermometer, the juices of the chicken are running clear and the spices are golden and crisp. Remove the chicken pieces from the skillet and place on paper towel to drain off any excess oil, then season with salt and serve immediately.

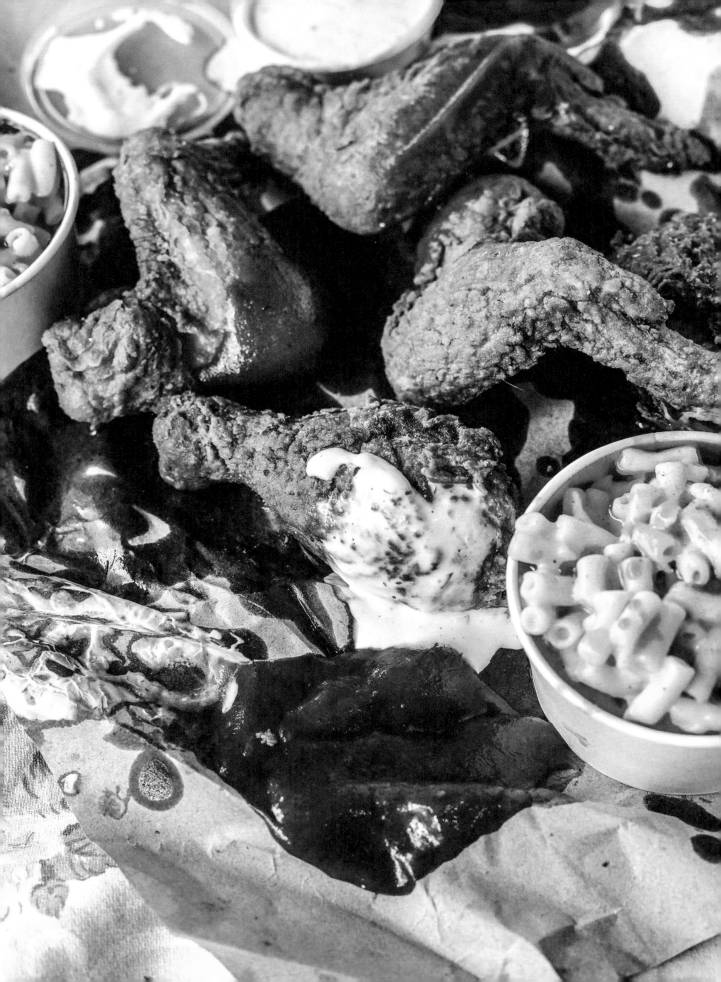

HOT MUSHROOMS

Mushrooms. In my experience you either love 'em or hate 'em—there seems to be no in-between, no middle ground. I've cooked them hundreds of ways for people who don't like them to very little success, but here's a recipe that seems to get even the strongest of haters on board. If you get this one right the polenta should create a seal and trap in the heat, steaming the mushroom and creating a firm, tofu-like texture.

Serves 4–6 as a side

4 smallish field mushrooms (each about the size of your palm), stems trimmed
250 ml (8½ fl oz/1 cup) buttermilk
400 g (14 oz/2⅔ cups) cornmeal polenta
vegetable oil or lard, for deep-frying
sea salt
white bread slices, to serve

Spiced flour
200 g (7 oz/1¼ cups) plain (all-purpose) flour
1 tablespoon dried oregano
1 tablespoon dried sage
½ teaspoon white pepper
pinch of salt flakes

Sauce
100 g (3½ oz) butter
1 teaspoon smoked paprika
1 teaspoon habanero powder
pinch of salt flakes
1 tablespoon apple-cider vinegar

For the spiced flour, mix together all the ingredients in a large bowl.

Add the mushrooms to the bowl and toss them together with the flour mixture to coat. Remove the mushrooms from the bowl and set aside, then transfer the excess flour mixture from the bowl to a zip-lock bag (ready for the next time you make this). Pour the buttermilk into the bowl.

Add the polenta to a separate large bowl.

Taking one mushroom, dip it first into the buttermilk and then into the polenta so that it is completely covered. Place it on a tray, then repeat with the remaining mushrooms. Once all the mushrooms are coated, transfer the tray to the fridge and leave for at least 1 hour to chill.

To make the sauce, gently melt the butter in a small saucepan over a low heat. Stir in the rest of the ingredients and keep warm until needed.

When ready to cook, half-fill a heavy-based skillet, saucepan or deep-fryer with oil or melted lard and heat to 185°C (365°F).

Carefully lower the mushrooms into the hot fat and cook, turning every 30 seconds so that they cook evenly, for 3 minutes or until golden. Remove and drain on paper towel. Season well with salt.

To serve, lay the mushrooms on slices of white bread and pour over the warm sauce to finish.

MAC 'N' CHEESE

You can really use whatever cheese you like here—I like to use equal parts gouda, smoked gouda and cheddar. I've dusted the mac with a little smoked paprika and dived right in after covering it with the cheese sauce, but it's also good spooned into an ovenproof dish, covered in breadcrumbs and baked in a 200°C (400°F) oven for 20 minutes.

Serves 4–6 as a side

250 g (9 oz) macaroni
150 g (5½ oz) butter
150 g (5½ oz/1 cup) plain (all-purpose) flour
½ teaspoon ground nutmeg
2 fresh or dried bay leaves
1 cardamom pod
½ onion
2 teaspoons salt
1 teaspoon white pepper
1 litre (34 fl oz/4 cups) milk
300 g (10½ oz) shredded cheese mix (such as gouda, cheddar etc.)
smoked paprika, to serve

Boil the macaroni according to the packet instructions until just cooked. Strain and run under cold water for 5 minutes, then set aside in a dish.

Melt the butter in a large heavy-based saucepan over a low heat. Add the flour a tablespoon at a time, stirring continuously, to form a smooth paste (roux). Continue to cook, stirring, for 8 minutes to cook out the taste of the flour, being careful not to burn the paste as you go.

Continuing to stir, add the nutmeg, bay leaves, cardamom, onion, salt, white pepper and milk to the pan, and cook, lowering the heat if necessary to prevent the milk from boiling or catching on the bottom and burning, until the mixture has thickened enough to coat the back of a spoon.

Strain the mixture through a fine sieve to remove the spices and onion, then return to the pan together with the cheese and stir together over a medium heat until the cheese has melted and combined.

To serve, pour the hot cheese sauce over the macaroni and mix through until all the pasta is coated. Spoon into bowls, sprinkle over a little smoked paprika and dive in.

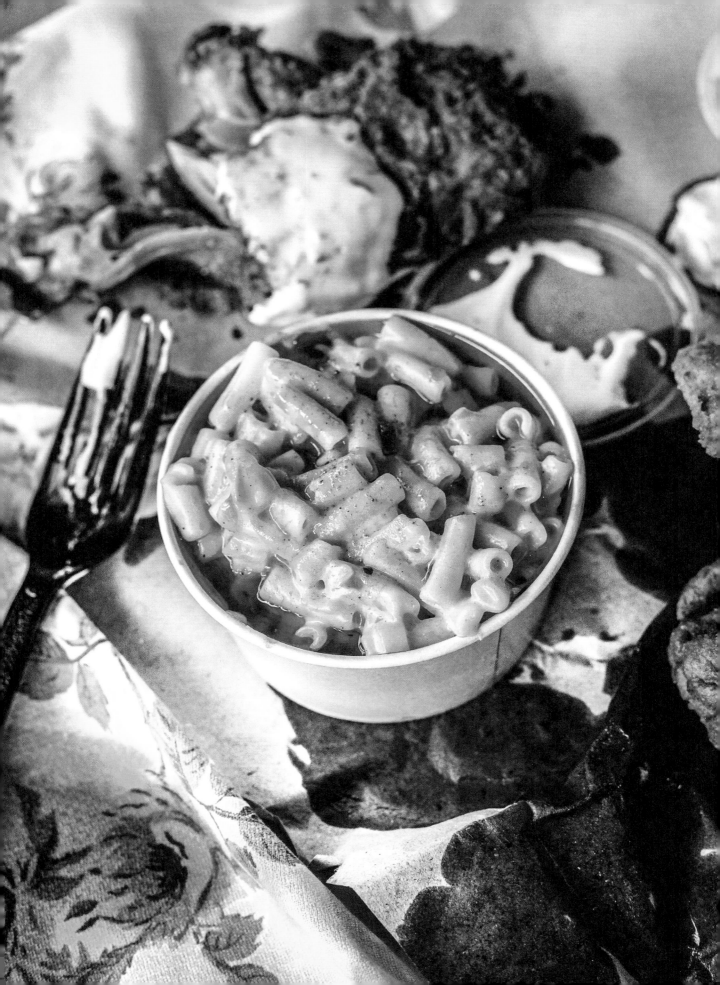

A REALLY BASIC HOT SAUCE

You only need four things for this recipe—chillies, table salt, vinegar and time. Well, actually, that's a lie, as you also need xanthan gum to thicken it up. But that's it, I promise.

The first step here is to buy a lot of chillies (if you have a market nearby ask for seconds, as they will be cheaper and better). Now, depending on how hot you like your hot sauce you can use whatever chillies you like. I use long red ones because, basically, I don't want the sauce to melt my face and I prefer to taste the flavour and not completely ruin my day when I eat it.

Now, for a few tips. 1. Be sure not to throw away the pulp here as it's great for use around the kitchen—try tossing a teaspoon of it through pasta, or add it to your seafood or barbecue favourites. And 2. (A note from someone who's been there before.) Be sure to wear kitchen gloves throughout, and do not go to the toilet until you have washed your hands at least three times after making this.

Makes 2 × 250 ml (8½ fl oz/1 cup) bottles

1 kg (2 lb 3 oz) long red chillies, or other chillies of choice
approx. 200 g (7 oz) table salt
apple-cider vinegar
xanthan gum, for sprinkling

Blitz the chillies in a blender to a wet pulp, then transfer to a tall, sterilised container or jar (see page 49). Cover the pulp with a layer of salt approximately 2.5 cm (1 in) deep, being careful to cover all the exposed surface area to create a seal, then cover with a breathable cloth.

Store the container in a cupboard or other dark place and leave for 6 weeks, checking on it occasionally to make sure no mould is forming on the surface of the salt (if it looks like there is, scoop it off and replace it with a fresh layer).

After enough time has passed, carefully scoop the salt cap off and discard, then pass the chilli pulp through a fine-mesh sieve, collecting the liquid in a clean container and pressing hard on the chillies to extract as much of it as possible.

To finish the sauce, weigh out the liquid and add 20 per cent of that weight in apple-cider vinegar. Using a hand-held blender, blitz everything together for 5 minutes, being careful not to get the liquid hot, then lightly sprinkle a little xanthan gum over the surface and blend for another 3 minutes, or until the sauce has thickened to a Tabasco-like consistency. Pour into sterilised bottles and seal until needed (it will keep pretty much forever in the pantry).

RANCH DRESSING

The king of just about anything you can imagine. If you can dream it, you can smother it in ranch.

Makes 500 ml (17 fl oz/2 cups)

250 ml (8½ fl oz/1 cup) buttermilk
80 g (2¾ oz) whole-egg mayonnaise
150 g (5½ oz) sour cream
1 tablespoon water
½ teaspoon onion powder
½ teaspoon garlic powder
1 tablespoon apple-cider vinegar, plus extra if needed
pinch of white pepper
pinch of salt flakes, plus extra if needed
½ bunch of flat-leaf parsley, finely chopped

Whisk all the ingredients together in a bowl, then taste and adjust the seasoning if necessary with more salt or acid. Store in an airtight container in the fridge until needed (it will keep for up to 4 weeks).

APPLE BUTTER

This is best made in a slow cooker, though it can also be attempted on the stovetop—just be mindful it doesn't get too hot or you'll burn the apples. It's perfect with waffles and fried chicken.

Makes about 400 g (14 oz)

8 large pink lady apples, roughly chopped
200 g (7 oz) soft brown sugar
½ teaspoon ground cinnamon
½ teaspoon ground allspice
¼ teaspoon ground nutmeg
pinch of salt flakes

Add all the ingredients to a bowl and mix well to combine. Transfer to a slow cooker, cover with a lid and cook on low for 10 hours, stirring every now and then. Uncover and, using a hand-held blender, whiz to a purée, then continue to cook on high for a further 2 or so hours, until thickened. You can serve this hot or cold and it will keep refrigerated for up to 2 months.

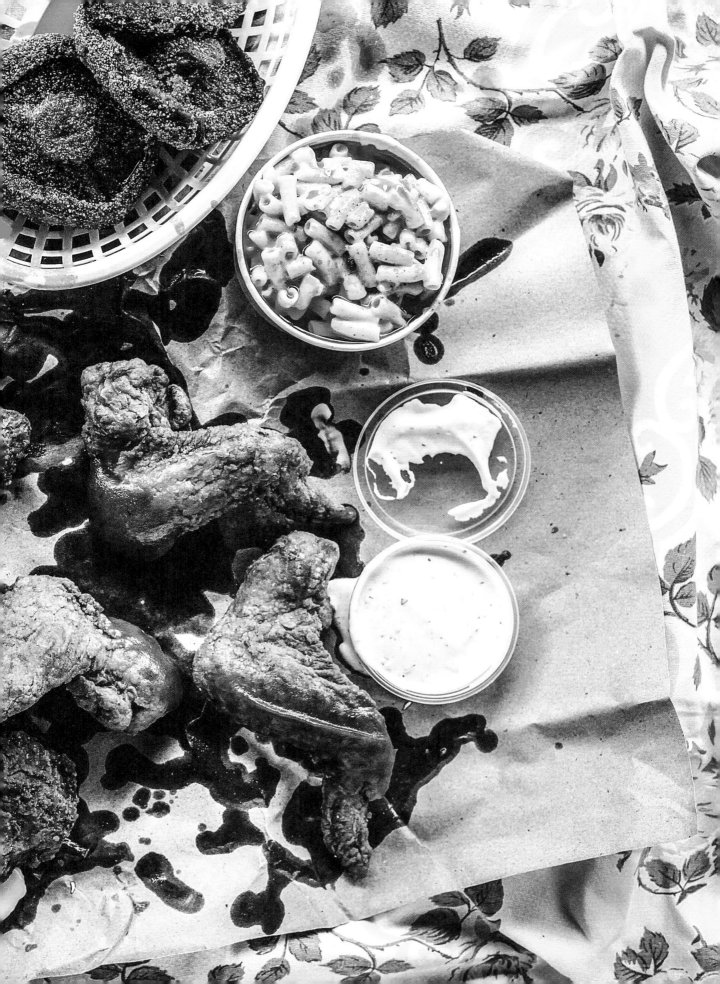

There's a place I want to show you, the place where it all started to change.

It's not far from Prince's, just a quick drive south, back towards the neon lights.

It's late and the southern summer night has the air thick and humid, quiet and still.

We can roll the windows down to catch a breeze, blasting The Nashville Sound on the stereo as we drive through the neighbourhoods.

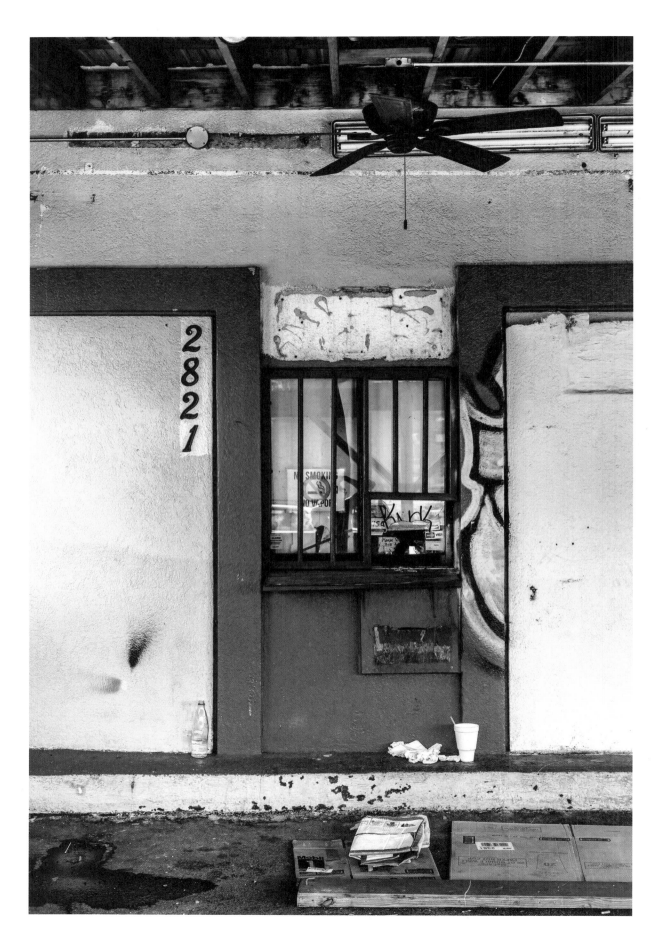

PEPPERFIRE

That was it there, on the right. You'll notice it's abandoned—that red and tan shack standing alone and beginning to fall apart. That's where it used to be, where it all started. That's where the new generation of hot chicken was baptised.

On the left is a smokes and liquor market where someone was shot and killed in broad daylight. Says all you need to know about the neighbourhood, I guess. It's a risk, but one I was always willing to take, for the chicken.

When you look down the side the only thing suggesting its past is an empty and graffitied drive-through sign. The carpark is starting to rubble, the grass forcing its way through the cracks and broken edges of where the old dining room was, the humidity helping the jungle reclaim its ground.

This building is more important than you think, though you'd be forgiven if you skipped it. Its current condition doesn't tell you much about its importance.

It housed a restaurant called Pepperfire, a hot chicken joint that would, without its owners realising it, become the flag-bearer for and quiet beacon of change. Without knowing it they lit a torch for what was to come—the gentrification of this fiery bird as it slowly crept out of the neighbourhoods and onto a national and eventually global stage.

I loved this old place. Like Prince's, it just felt right. Homely, comforting. Occupying an old standalone on Gallatin Pike, picnic tables for seating, no bathroom, no shelter from the elements. It was an open-air barn of sorts. I'm not sure when, but they moved to a new location. Not far from here, a little further south, a little closer to the city's growing skyline. A better location, bigger, weather-friendly and with more room to do what they do best—cook.

The owner, Isaac, a self-proclaimed evangelist, is a man on a mission to spread the good word, the Gospel of Hot Chicken, to as many people as will listen. A man who believes he was born to do something with hot chicken. A man who, on first tasting it, became obsessed.

Sound familiar?

Before opening Pepperfire, before changing his life to pursue his own version of the perfect bird, he spent ten years visiting and eating at places like Prince's. Ten years spent dissecting which spices to use, what the best fats were to fry in, searching for the best process before cooking—each step equally as important as the next. He would critique every part of the process, never content that he had it perfected, always questioning. Was it better to use Amish-raised chicken or does a cheaper bird fry better? Were the spices in his mix better if they were ground fresh daily or left to sit in order to gain a more developed flavour? Every piece of the hot chicken puzzle was unpacked and put back together to perfect his way, the Pepperfire way. He was determined to do what he loved and do justice to a recipe like Thornton's.

You've gotta admire that, don't you think? His passion and drive to do his version of the best bird he can, without compromise. Holding himself and others hostage in pursuit of the perfect chicken fry.

I get it. He's a perfectionist. A lover. An obsessive.

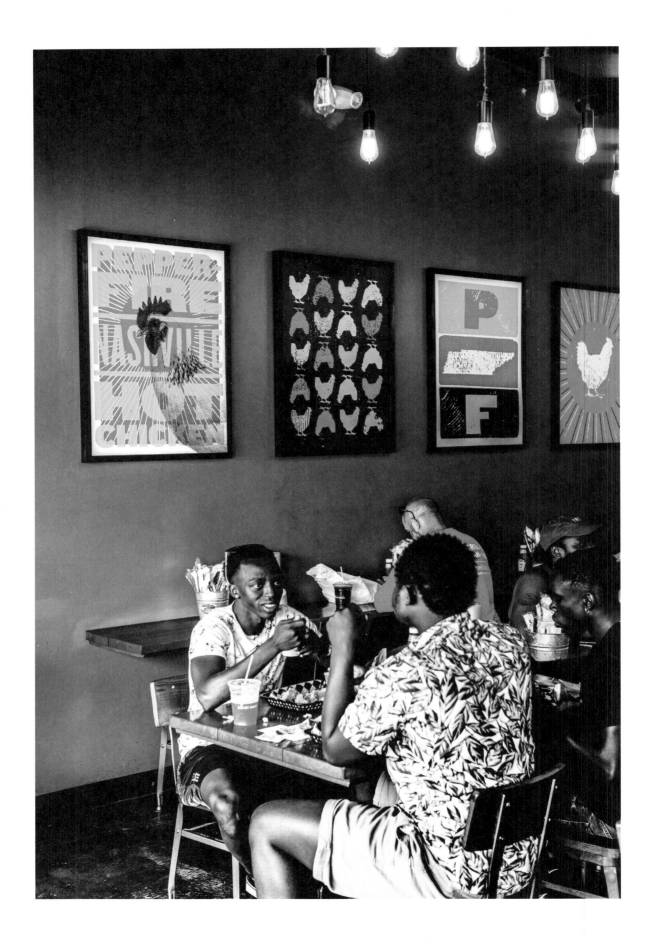

The menu reads a little differently to Prince's. Among the usual wings, tenders, legs and breast quarters they also up the ante and offer a half or whole "Hot Bird". Waffles also make an appearance, and delicious fried okra sits alongside mac 'n' cheese as a side option.

But let me tell you about their tender Royale—the heart-stopper, I call it. A fried pepper cheese sandwich topped with three tenders, any heat you like. It's not as crazy as some of the things they do in this city, but they level it up with a dish that has seen them hunted down and celebrated nationwide, with TV hosts lining up to see who can conquer it.

It goes something like this:

Four deep-fried white-bread pepper cheese sandwiches, topped with almost two pounds of tenders—and these tenders are big, I swear they are from a turkey—each coated and smothered in a spice mix so perfectly dark and foreboding you start to sweat and sneeze just looking at it. That's the first thing you'll notice at Pepperfire, how much darker the chicken is here, with a complex layer of spice coating a much lighter, thinner crust. (There's a rumour that Carolina Reapers, known to be the hottest peppers in the world, are involved.) All this is then topped with one-and-a-third pounds of cooked apples, coated with a rich cinnamon sauce.

It's a lot just to look at and, I agree, a lot of fried stuff on top of fried stuff, but you gotta trust me on this, it's really good. Perfectly sweet and crispy and holy shit, it's hot. I mean, I did order it XX HOT, and they do warn you the heat will jump on you and not let go. I gotta tell you, no truer words have ever been spoken. This heat will turn your stomach inside out, leaving you cursing the far reaches of heaven and hell as your insides battle for relief. It's Undertaker vs Mankind. Hell in a Cell. And it has the perfect name—The Battle Royale.

The other thing here that I love—and for a long time they were the only ones doing it—is their hot chicken sandwich. I used to come every Saturday for one of these before hitting the Crying Wolf for a few afternoon beers in the sun. It was my ritual, usually a cure-all from the night before.

The sandwich is simple, unlike the Royale. There's no fucking around here, just jumbo tenders—any heat you like—fried succulent and crisp, a thick-cut slice of perfectly ripe tomato (those things ripen in the southern sun like nowhere else on earth), crisp lettuce and blue cheese on a butter bun. That's it.

The cooks rely on each individual ingredient to be just right: the produce, the cook, leaving no room to hide. If you fuck it up, it's glaringly obvious.

Another thing they do a little differently here that I like—it's a small thing, but they make a skin-on red-potato salad. It can be a contentious issue, skin on or skin off. People with their own recipes will have their own "correct" dos and don'ts that can lead to arguments so fierce they can divide a family. Trust me, my family argues all the time over who makes the best potato salad. And it doesn't end with the skin debate. It continues with the correct way to cut the potatoes, if at all, as well as which method cooks the best potato—boiled or steamed. (Steaming doesn't break up the potatoes like a rapid boil will but ideally I prefer a mix of both.) Either way, you need to let the potatoes sit after cooking until completely cooled and easy to handle, leaving the flesh dense, so that the texture of the skin that's been boiled or steamed develops a paper-like chew. It's an important step in making a potato salad.

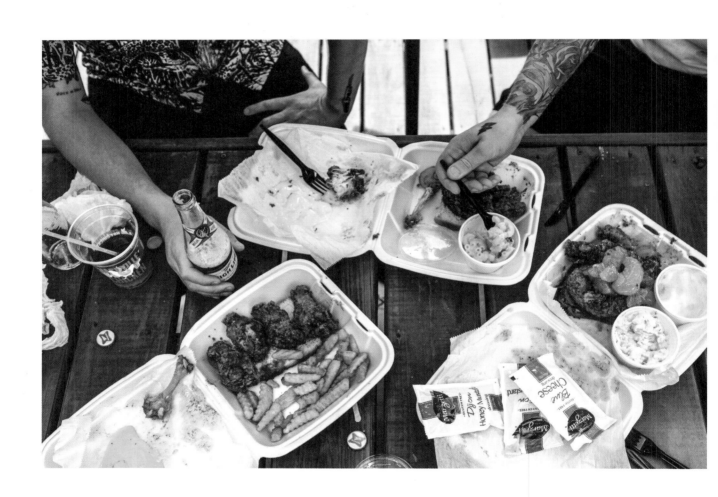

I say we start with some tenders in light mild, as an entry point into the world of Pepperfire. I'll also get the half chicken, mild, but don't be fooled by the word mild—it's a noticeable burn here at Pepperfire. The spice blends have a depth to them, individual layers of flavour you can taste, which is not surprising. After all, Pepperfire is the result of ten long years of working on each part of this dish.

If there's any rule to follow when ordering any sort of chicken, fried or otherwise, it's that you should always order wings. *Always*, no exception.

A six serving should do, coated in hot spice that comes with a warning that this level is painful for most.

I'm starting to get excited, wings do that to me—the wingette, drumstick and flapper a perfect mix of crispy skin and sticky, collagen-rich flesh. The anticipation of ripping them apart, gnawing at the bones, stripping them clean, fingers stained orangey red, nose running, eyes watering, lips burning. It's bliss.

Wait, maybe I should get the ten-piece serving? After all, who knows when I'll get here again.

Let's also do a serve of tenders XX HOT, a side of fried okra, the potato salad, seasoned fries, of course, and the collard greens, which have been braised for hours in a rich stock of pork knuckles and bones.

And of course, I completely forgot, I'll take one of the hot chicken sandwiches.

I promise it's gonna be good. You can smell the spices in the air. Hear the sound of the chicken hitting the fryer.

It's a thing of beauty.

I'm going to start in on one of these tenders. They're the easiest way to eat the hottest spice because there's little or no lip contact—you can just dive straight in with the tongue being the only contact point. Tender eaters usually use a knife and fork—you ever noticed that? Strange folk, those tender eaters: they always brag how they can eat the hottest of hot while also claiming *it's not even that hot*! It makes me laugh. Talk to me when you've had it on a serve of wings or piece of dark meat. That usually sorts them out. And no cutlery either—you can't really help but touch your lips, eyes and nose when you eat off the bone. The chilli doesn't just burn your lips, it clings on to every sensitive area you didn't even know you'd touched, anywhere it can get a hold of.

The heat at Pepperfire really does what it says it will—it grabs you on the first bite and with each mouthful it holds on and won't let go, even on the tenders.

Sweet Jesus, it feels like my tongue is swelling. Every mouthful only increases the pain but, fuck me, it's delicious. I know the next step: bloodshot eyes and tears and those embarrassing hiccups and sneezes, but I just can't stop eating. I *won't* stop eating.

This is what it does, hot chicken. You just can't stop. And you don't want to. And why would you? Mouthful after mouthful hotter and hotter, building and building and more painful with each bite—a moment of both absolute pleasure and pain.

Now, I can't even tell if I'm dribbling—my eyes, nose, mouth are numb, my lips and tongue have been rendered useless. The red-streaked white bread underneath offers me almost no relief, soaked through as it is with all the spices. The pickles are long gone in an early, futile attempt at providing a cooling refuge, the only choice left is to ride the wave of the chilli-induced high.

Thornton's niece André calls it twenty-four-hour chicken, "cause you'll be feeling the wrath long after the eating's done and well into the night and next morning as your stomach curdles and bubbles in pain while your intestines fight for relief from last night's dinner".

I know progress is inevitable and you can't begrudge it of anyone, but the hopeless romantic in me wishes Pepperfire was still in that old abandoned red and tan drive-through where I could roll up hungover from the night before, order at the cut-out window and sit alone at the picnic tables eating a sobering hot chicken sandwich.

But that's how it goes in a changing skyline, things change. What hasn't changed here, though, is the passion for the bird— it's second to none. And for the new generation of chicken slingers, well, it's in good hands.

COLD FRIED CHICKEN SANDWICH

Hangovers, broken hearts … a cold fried chicken sandwich will fix pretty much anything. And, just like most sandwiches, it tastes a thousand times better if someone else makes it for you.

The secret is to make—or order—more fried chicken than you need and let it sit in the fridge for a day or two first, so that you're good to go. And make sure you have some cheap white bread in the house—thick cut is best but, in all honesty, any will do.

Makes as many as you like

white bread (the cheaper the better)
whole-egg mayonnaise
iceberg lettuce leaves
sliced cheese
leftover boneless fried chicken (any kind)
hot sauce of your choice

Smother two slices of bread in mayo and cover with pieces of crisp iceberg lettuce and cheese.
Slice the cold fried chicken and season well with your favourite hot sauce.
Put it all together.
Repeat as needed.

BOLOGNA SANDWICH

They tell me you can't eat fried chicken every day, so here's another sandwich option for you. Inspired by the Recession Special—a fried bologna sandwich, a Bud and bag of chips for $5—available at the great Nashville honky-tonk Robert's Western World, this is a simple but life-changing sandwich, made with sliced and fried bologna, tomato and cheese.

Now, if you've ever eaten a properly ripened tomato you'll most likely know it's all you need for a great meal. But add a fatty piece of mystery meat and some cheese to the deal and … well, you get the idea.

Makes 4

1 tablespoon butter
1 tablespoon olive oil, plus extra for drizzling
4 thick bologna slices (approx. 120 g/4½ oz each)
150 g (5½ oz/1 cup) Spiced Flour Mix (see page 189)
4 cheese slices
2 large ripe beefsteak tomatoes
salt and white pepper
4 milk buns
84a Sauce (see page 49), to serve
1 handful of crisp red coral lettuce leaves

Heat the butter and oil together in a frying pan over a medium heat until the butter begins to foam.

Dust the bologna slices with the spiced flour and fry until golden and crisp, about 2 minutes on each side.

Remove the bologna slices from the pan and lay a cheese slice over each so that they start to melt.

Cut the tomatoes into finger-thick slices, season generously with salt and white pepper and drizzle with a little olive oil. Slice the buns in half.

To serve, spread 84a sauce generously over the cut sides of the buns. Taking one bun half, layer it up with some lettuce leaves and place the bologna on top, then pile over some tomato slices and sandwich everything together with a bun top to finish. Repeat with the rest of the buns. You're done.

TOMATO-BRAISED OKRA

Okra can be—and usually is—bad. Cooked for too long it becomes slimy, not long enough and it's chalky and acrid. This method will help keep the okra from becoming gummy and, so long as you cook it till tender, you will avoid that unpleasant chalky taste, too.

Serves 4 as a side

300 g (10½ oz) okra
1 tablespoon salt flakes
juice of 1½ lemons, plus extra to serve
400 g (14 oz) tinned tomatoes
1 tablespoon smoked paprika
1 tablespoon lard
1 white onion, grated
4 garlic cloves, very finely chopped
100 ml (3½ fl oz) olive oil
1 bunch of flat-leaf parsley, finely chopped
4 tomatoes, sliced
cracked black pepper

Trim away the okra ends, toss the remainder into a strainer with the salt and the juice of half a lemon and leave it to sit in the sink for 30 minutes. Rinse well under cold water and pat dry.

Add the tinned tomatoes and smoked paprika to a blender and blitz to a purée.

Warm the lard in a heavy-based skillet or frying pan over medium heat, add the onion and garlic and cook for 4–5 minutes, or until soft. Add the puréed tomato mixture together with the olive oil, parsley and the juice of 1 lemon, cover with a lid and cook over a low heat for 15 minutes, or until the sauce has started to reduce and thicken.

Add the okra to the pan, layer over the tomato slices and season with salt and cracked pepper, then cook, covered, for a further 10–15 minutes, or until the okra is tender and just cooked through.

To serve, pile the okra into a bowl or container and squeeze some more lemon juice over the top to finish.

POTATO SALAD

Some people like to peel the potatoes for this salad before cooking them, others don't. Some like to peel them after the cooking and others … well, others just leave the skins on. To be honest, I like this salad however it's done—I'll leave it up to you and whatever you have time for.

When cooking your potatoes, be careful not to let a rapid boil creep in as it will break them apart and ruin your salad. If that does happen, you can always turn them into a mashed potato—just add a lot of butter and crush them with a fork, then season with salt and cracked pepper and serve with a quickly made gravy poured over the top.

Serves 6–8 as a side

1 kg (2 lb 3 oz) medium-sized desiree potatoes (or other all-purpose potatoes)
2 granny smith apples (or other tart cooking apples), peeled, cored and diced
1 red onion, finely diced
6 pickles (gherkins), diced
3 tablespoons dijon mustard
200 g (7 oz) whole-egg mayonnaise
½ teaspoon white pepper, plus extra if needed
1 tablespoon salt flakes, plus extra if needed
80 ml (2½ fl oz/⅓ cup) apple-cider vinegar, plus extra if needed
1 bunch of dill, fronds finely chopped

Place the potatoes in a large pot, cover with cold water and slowly bring to a gentle boil. Cook for 8 minutes, or until the potatoes are just cooked and tender when pierced with the tip of a sharp knife. Gently strain the potatoes and leave to cool.

While the potatoes are cooling, mix all the remaining ingredients together in a large bowl.

Once the potatoes are cool enough to handle and the steam has dried them out a little, carefully cut them into rough walnut-sized pieces. (You don't want the potato pieces to break up when you do this, so be gentle as you handle them.)

Add the potato pieces to the dressing and carefully fold them through to coat completely. Taste and add more salt, pepper or vinegar as needed (I always end up adding a little of all three). Serve.

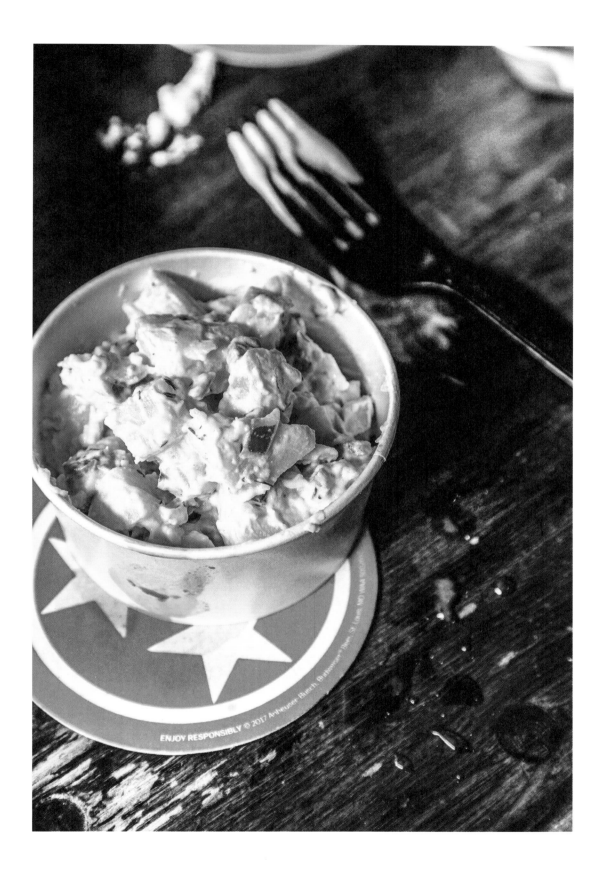

FRIED DILL PICKLES

These little bites make the perfect snack with a cold beer for any time of day. Store-bought crinkle-cut dill pickles work best for this—just be sure to drain them well before using.

Serves 6–8

vegetable oil or lard, for deep-frying
500 g (1 lb 2 oz) dill pickle (gherkin) slices
Ranch Dressing (see page 81), to serve (optional)

Seasoning
1 tablespoon coriander seeds
1 tablespoon celery seeds
1 tablespoon fennel seeds
1 tablespoon dried oregano
1 tablespoon hot paprika
1 tablespoon salt flakes

Batter
250 g (9 oz/1²/₃ cups) plain (all-purpose) flour
250 g (9 oz/1²/₃ cups) cornmeal
1 teaspoon onion powder
1 teaspoon garlic powder
1 teaspoon tomato powder
1 teaspoon salt flakes
a pinch of white pepper
330 ml (11 fl oz) cheap beer, plus extra if needed

To make the seasoning, put all the ingredients into a spice grinder and blitz together to a fine powder. Set aside.

Mix the batter ingredients together, slowly whisking in enough cold beer to make a thinnish batter that just holds together and lightly coats a finger.

Half-fill a heavy-based skillet, saucepan or deep-fryer with oil or lard and heat to 185°C (350°F).

Working in batches, dip a handful of the pickle slices into the batter, then drop them into hot oil. Fry for 2 minutes until golden and crisp, moving the slices around as needed so they don't stick together and making sure not to let your oil drop temperature.

Serve with a generous sprinkling of the seasoning and smother in ranch dressing if you like (I do).

A GOOD ALL-ROUND SEASONING

A good seasoning is one of the most important weapons you can have in your culinary arsenal—it can be used on pretty much anything you cook, and is very often the difference between a nicely seasoned dinner and one that just gets the job done.

Makes 300 g (10½ oz)

50 g (1¾ oz) smoked paprika
50 g (1¾ oz) dried sage
200 g (7 oz) table salt

Add the smoked paprika, sage and half the salt to a spice grinder and grind until fine. Transfer to an airtight container with the remaining salt and mix together well. Store until needed (this will keep pretty much forever).

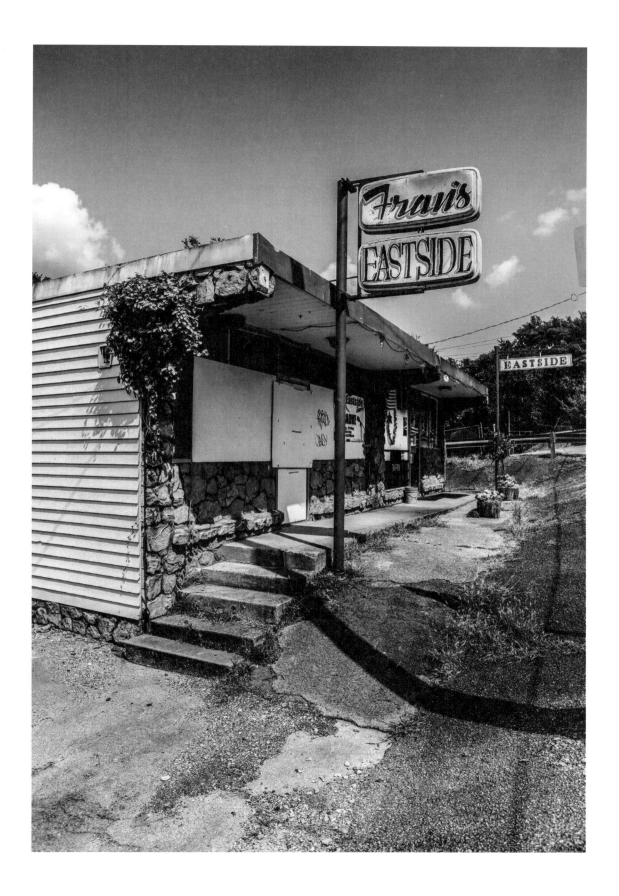

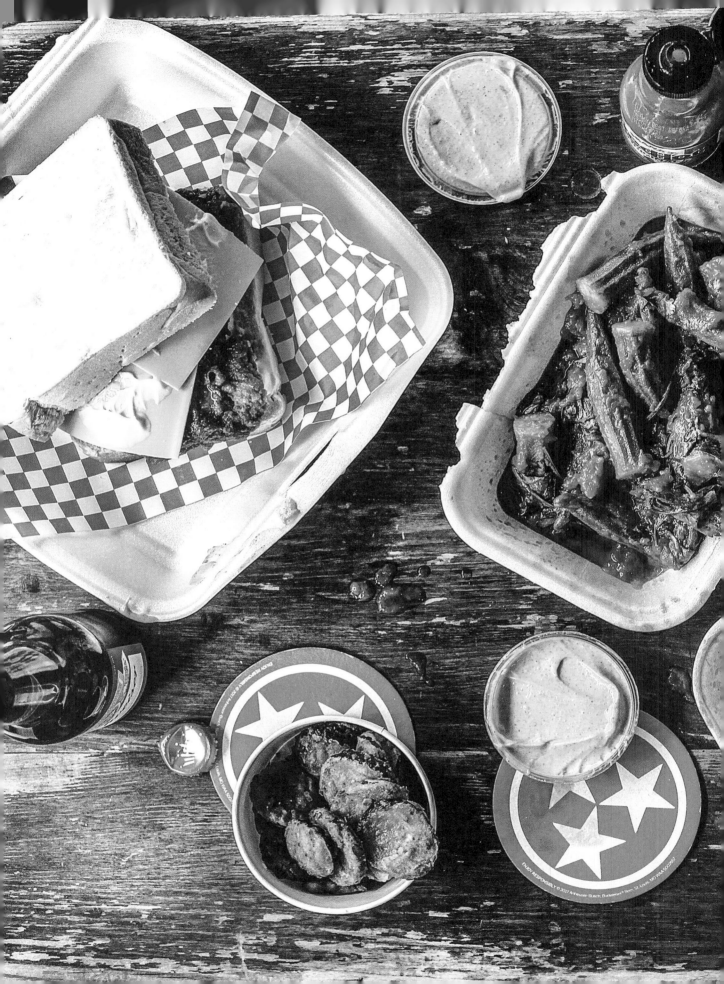

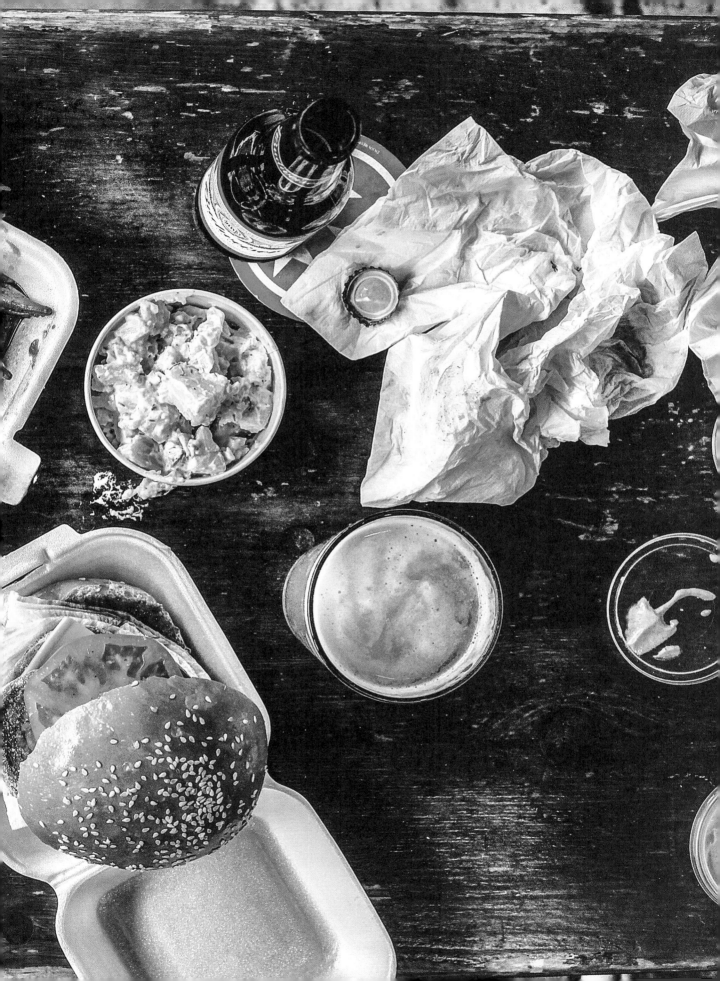

There's a place, not far from here, a little further south, out on the fringes of the city.

Its importance is often not told in Nashville folklore, but important it is.

I fucking love this place.

Bolton's Spicy Chicken and Fish.

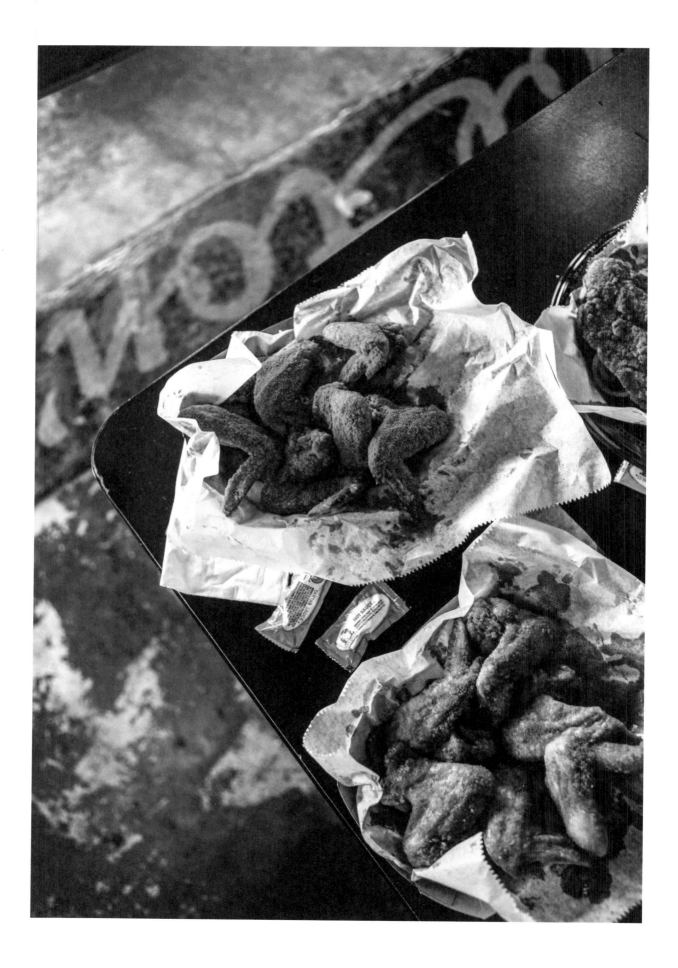

BOLTON'S SPICY CHICKEN AND FISH

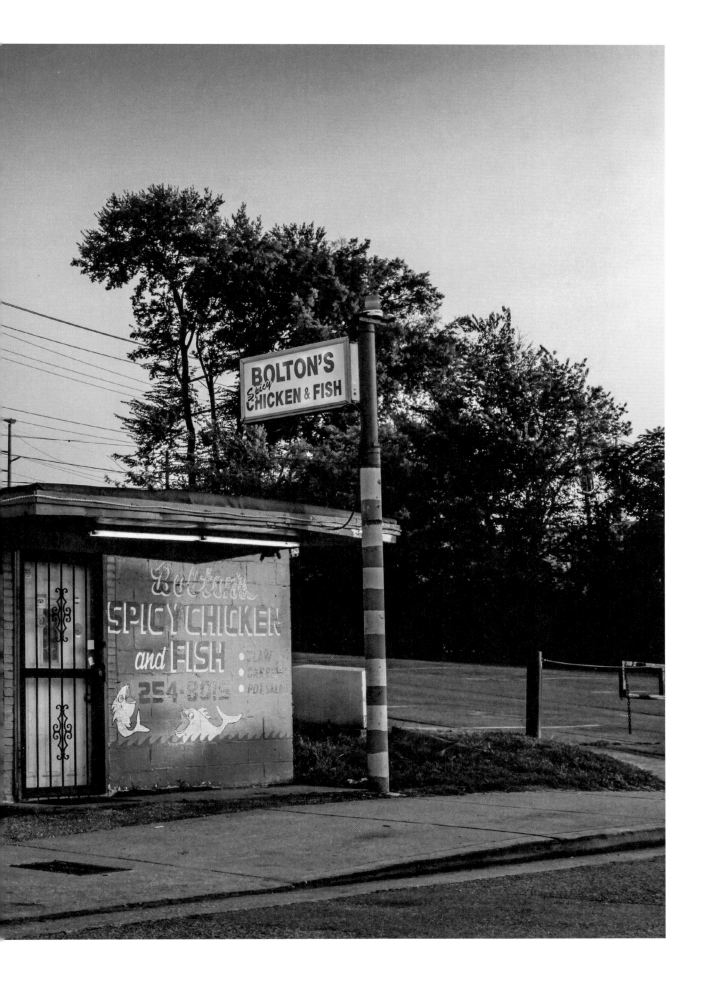

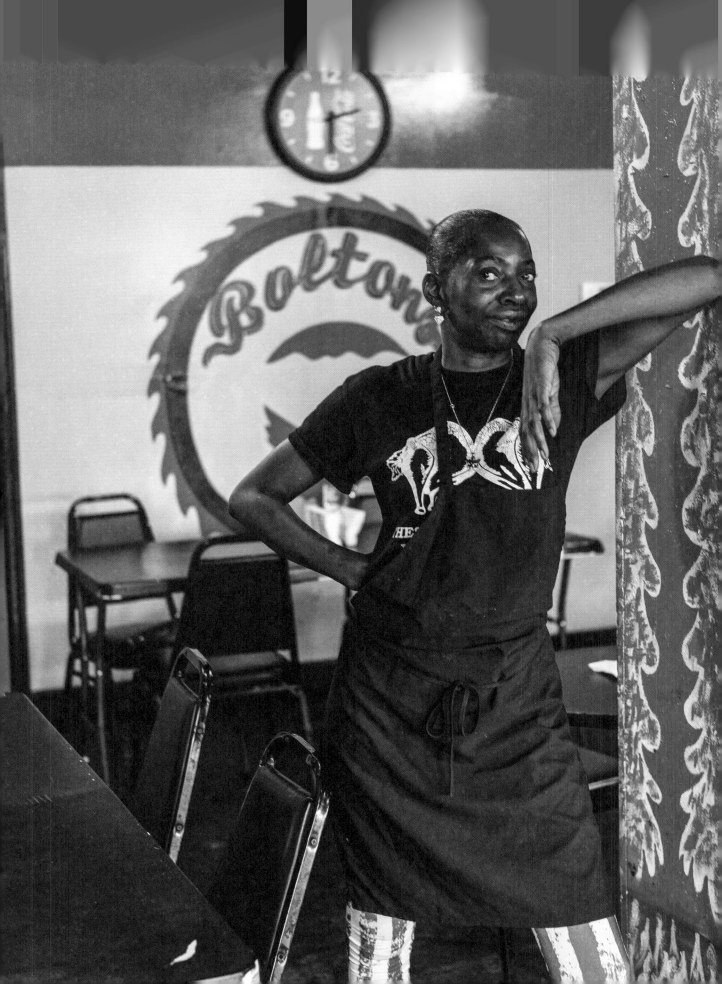

"Stop wriggling, man, lemme hold these cold towels on your goddamn eyes."

"You gone done what every newbie's done, you rubbed ya eyes, didn't ya?"

"Y'all can shut the fuck up and stop laughing, sittin' there eatin' ya southern fried."

"Now, tilt your head back and lemme pour this cold water in those swollen eyes—and quit your bitchin', son, you ain't goin' blind."

This is it for me, isn't it? I've blinded myself on Bolton's hot chicken. I've gone and rubbed the goddamn cayenne right into my eyes and my whole head feels like someone set fire to it.

When you get Bolton's spice rub in your eyes, it feels like someone is forcing your eyelids open with fire needles and pouring sand directly into your eyes while someone else shoots a flamethrower at your face. If you can picture your face melting and bubbling away like the Toxic Avenger's, you'll start to get an idea of what it's like eating the extra-spicy wings here at Bolton's Spicy Chicken and Fish.

This is what happened to me the first time I ate in the shack on the city's fringe.

But how could anyone resist those wings when they are such a thing of beauty? Powder bombed, illuminated bright orange from their dry rub of cayenne and god-knows-what-else, glistening with skillet fat and accompanied by the nose-burning smell of hot chilli powder.

They're an ominous warning of what's to come.

Eating at Bolton's feels like landing at the gates of hell, meeting the devil Lucifer himself and having him baptise you again and again and again into the world of hot chicken.

But hey, at least this time I'm not alone. I know that guy over there in the other booth, a rockabilly guy covered in tattoos, passed out into his Styrofoam plate of chicken. I've been there before, face down in a pile of chicken bones, drunk from a night out at the Batters Box.

There's no bullshit here. It's straightforward, no messing around. This blue- and grey-walled bunker on the edge of the new Nashville isn't where Bolton's first started. This neighbourhood wasn't always like this—the chain-smoking, tattooed, craft-beer drinkers turned up East as the city encroached. This is where Bolton Polk's nephew and name-sake Bolton Matthews took the reins and reopened what had been started decades ago at a place called Columbo's.

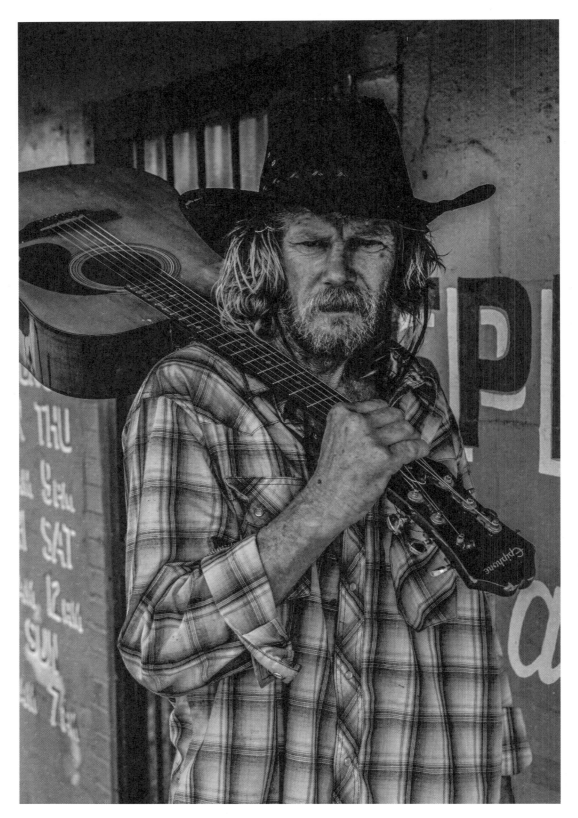

Busker outside Bolton's Spicy Chicken and Fish, 624 Main Street, Nashville, TN

Now, we'll get to eating soon enough, but first let's address the elephant in the room—the history between Bolton and Thornton. Thornton the master and Bolton the cook.

Bolton worked day and night at Prince's shack downtown on Charlotte Avenue doing everything possible, day in, day out, night after night, to cook the best damn chicken he could. Slingin' bird to the city of Nashville alongside Thornton and the brothers Prince.

I'm not one to guess, and no one can really tell me what happened between the two of them. But that's partly why I'm here, to get the full story.

So, what went down?

Was it a fight over the best way to prepare the chicken? Or was it about which were the best spices to use or what the best shortening was? Or maybe it was just too many late nights bathed in heat, frying that chicken golden, drinking bourbon and courting women?

It's old history, I suppose. And maybe it's better left at that. Time to move on, what's past is past. But you gotta admit, it's an interesting story. The disgruntled chef, the cook who spent years as the guardian to a family recipe, one day takes off to open his own place. Just makes a person wonder why, is all.

Maybe it's just not that important, why Bolton left. Maybe he just saw an opportunity to do something for himself, so he took it. Maybe it really was that simple, and people like me are reading too much into it.

But still, you gotta love old town folklore. A tale of chicken so spicy that the devil himself finds it hot. A lover scorned. A disgruntled cook. It's a story built for Hollywood.

There were neighbourhood whispers that arose when Bolton left Prince's and opened Columbo's. People with nothing better to do would say he stole Thornton's recipe, made off with it like a thief in the night to open his own place.

But did he? It seems only fair to ask, even though it's a claim I struggle to believe, eating here today. It's just so different compared with what they do at Prince's. It's unique to Bolton's and Bolton's only.

I think about the wings here a lot. And by a lot I mean more than what's probably healthy for an adult man to think about someone else's chicken. It's just … these joints are so perfectly seasoned, spicy as molten lava, addictive as hell and unlike any others in town. In a pro move like no other they went straight up and crop-dusted them with an Agent Orange–like rub that stains your lips and fingers the colour of a southern sunset.

I wonder if that's how the wings were all those years ago when Bolton opened Columbo's in the same neighbourhood as Prince's. Maybe that's what he wanted to do at Prince's all along—to try things a little differently just to see what happened, to mess with the family recipe a little? I know what that feels like, wanting to leave your own mark, needing things done the way you see fit. Anything that strays outside of those lines, well, that can drive people like me to madness. Little things and big things can tip you over the edge, kitchen towels not folded right, slaw left unseasoned to dry out in the fridge or chicken not brined the way you like. It's one way—your way or the highway.

But it was the additions Bolton made at Columbo's chicken shack that had them coming back again and again. His wife's chess pie, with its crispy, crackly crust and a rich, silken buttermilk custard filling was a welcome change and a hit for those inflicted with the curse of a sweet tooth. And her potato salad, I've been told, was to die for.

It's rumoured Bolton never wrote down the recipe for his chicken, never kept it in a lock box hidden from everybody like the Colonel, instead preferring to keep it all to himself, safe and sound because it existed only in memory. When it came time to teach and pass it on through the family there were no pens, no pencils, no legal pads containing the recipe, no quantities, no methods, no seasonings. It was all taught face to face, hand to hand. It was only he who could teach it and only he who could show them how it was done. I like that, I hope it's true.

It can be hard to trust people in this game.

A lot of people say that there is no secret to Nashville chicken, that it's just fried chicken doused in cayenne so hot it will burn and blister your mouth. But we all know that's not true.

There's nuance in every detail, each step has little quirks and every cook, with his or her own recipe, adds bits and pieces to leave a personal stamp. We all have our own spice blend, our own preferred temperature to cook in and methods for breading the chicken, not to mention an opinion on what sides go best and how to make them the best. It's a very personal thing, this type of cooking.

After the city rezoned, as cities seem to do, Bolton moved his shack from downtown to just across the river, the Cumberland now separating his place from Prince's. The rent was cheaper and a whole new clientele was waiting. But years later, as Nashville started to expand, the city won its bid for a new football team. Almost overnight the Houston Oilers became the Tennessee Titans and, as sporting teams do, they needed a space on the city's doorstep where they could build a shiny new stadium. The land his restaurant traded on just across the river was quickly rezoned once again, forcing him to close Columbo's.

So just like that it was done. Everything Bolton had worked for, all those years slaving over the skillets, frying and seasoning the hot bird, every day spent perfecting his chicken, was gone and with it, the recipe.

Were there plans to open a third time? Perhaps somewhere deeper in the neighbourhoods? To keep bouncing around the city limits, like Prince's? I know it can be hard to keep starting again, that's why I ask. Was it still there—that passion to keep on going, to keep slingin' the bird every day?

Sadly, I read that he passed before ever getting a chance to make that decision. Luckily, and I mean this in the best possible way because it would be a culinary tragedy if he hadn't, at least he felt the need to teach his nephew, and namesake, Bolton Matthews, how to cook his chicken, passing on decades of knowledge about how things should be done the right way—*his* way, the Bolton's way—and without knowing it saved his own unique recipe from being lost to history forever.

I'm sure it would make him proud to know that, to this day, his nephew is still the only one who fixes the recipe. It's still not written down, and he's still keeping the family secret upstairs. His wife and business partner can only guess as to the ingredients; she claims it's probably made from pepper bomb spray for all she knows—and I'd tend to agree.

I wonder how the original Bolton would feel about some of the changes that have taken place since the new restaurant opened for the first time in 1997. From what I gather the new place has stayed true to Columbo's and to his recipes. I mean, why would you want to change that addictive dry rub anyway? The biggest change is the one that his nephew's business partner Dollye made, bringing her fish fry to the table. Catfish, tilapia and whiting given the Bolton's dry-rub treatment, pieces of perfectly fried fish, moist and steaming, encased in a tomb of cornmeal and spices, raw onion and mustard to finish. It's a masterstroke if you ask me, and one every bit as addictive as the chicken.

I like the location where they've reopened the place. It's a low-ceilinged bunker on the edge of new Nashville, just out east, skirting the city limits. It's where the neighbourhoods meet the city, the front line to the change happening so rapidly here in Nashville, with Bolton's holding ground right on the forefront.

Much like Prince's, there's no room for the bullshit here, just a few old pews, old worn wooden tables and a few chairs—all different—to rest on while you wait for your order to go.

A handwritten note is pinned to the pink door that reads, 'Knock when ready to order'.

What I wouldn't give right now to try a little of Bolton's wife's chess pie—a little slice of just-set custard, a perfect helping of cool to balance out the heat and spices. You gotta have something to offset this maddening heat.

I've said it before and I'll say it again. Bolton, you, sir, are the hottest motherfuckers in town.

I gotta imagine, too, that this is the sort of place the Colonel would have preferred. Real, honest, comforting. A place that smells of chicken frying, spices grinding, shortening heated and seasoned. That sounds of people talking, laughing, sharing stories of work, family and life's ups and downs while they wait for their plate of chicken fry, reminiscing about the last time they ate here.

I can only imagine his place was that way too, once. Even after making the deal with the devil to sell his recipe, he hated the new iterations so much he would argue and fight with his new overlords. Hell, as the face of the brand he would loudly and proudly preach to anyone who would listen that they stopped using his recipes years ago, and now it was just flour and shit, just like the gravy, telling reporters, "this food ain't fit for my dogs", which later brought a lawsuit from corporate for libel.

I like that, his undying passion and fire for his bird.

And this brings me to my favourite part of the Colonel's story, I think. At the age of eighty-four he tried to sue his own brand, the brand he was ambassador for, the brand that beamed his face all over the world and made him famous. Because, well, they were fucking up the chicken, his recipe, so bad he couldn't stand it.

Maybe this is what he really wanted the whole time—for his chicken to be in places like this, like Thornton's and Bolton's neighbourhood shacks instead. Jesus, those rejections must have been hard, those 1009 times people said no to him when he was peddling his recipe across the gas stations and restaurants of America. Most of us would have just given up.

I only bring this up here because Nashville is the place it all happened. It's the place where Jack Massey, the man responsible for turning the Colonel's recipe into everything he hated, lived.

All roads, it seems, lead us here, to Nashville.

I'm sure the Colonel would remember that day, March 6, 1964.

Somewhere in Shelbyville, papers in hand, he gritted his teeth and signed on the dotted line. Jack Massey, the millionaire businessman from Nashville, and the aggressive young lawyer John Y. Brown Jr from Kentucky, now owned not only his recipe but his image, for eternity. They promised never to tamper with his recipe and to keep quality a byline for the company, but none of that was true and deep down he'd have known it, I think. Contempt for what they were doing and what they would do would have hung heavy on him because, like for those of us sitting here right now in a fried chicken bunker on Franklin Pike, it's always been about the recipe, the quality, about that perfect piece of chicken.

I suppose it could have been Bolton or Thornton in that same situation, if Massey had only turned his attention towards them—towards the neighbourhoods and people who were right there in his own backyard. What if he had seen the business of hot chicken to be as lucrative as the Colonel's? We might be having a completely different discussion.

Would Bolton have taken the deal? Taken the loot and cashed out, leaving the businessmen to do what businessmen do? Would Thornton have given up the family recipe for a few dollars? How many would it have taken?

It's a question you probably can't answer until faced with a cheque with your name on it.

Those zeros can make a man do things he will later regret.

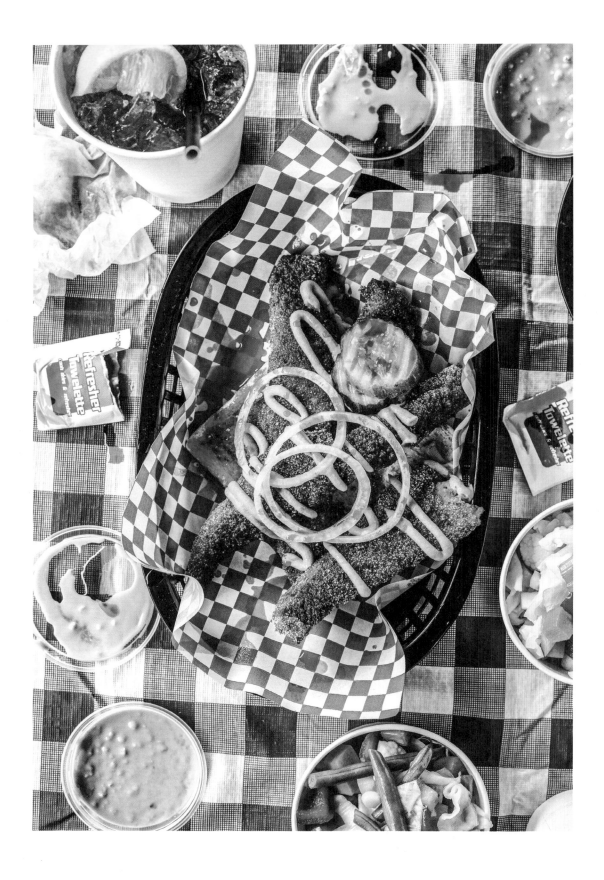

SPICY FISH SANDWICH

Ideally these sandwiches would be made with catfish, though flathead or king george whiting are great here too. If you don't have access to any of these then just use a good-quality local firm white fish.

Makes 4

8 × 125 g (4½ oz) catfish, flathead, king george whiting or other firm white fish fillets, bones removed
1 egg
400 ml (13½ fl oz/1⅔ cups) buttermilk
pinch of salt flakes
pinch of ground white pepper
400 g (14 oz/2⅔ cups) cornmeal
canola oil, for deep-frying

Seasoning
1 tablespoon chilli powder
1 tablespoon salt

Flour mix
200 g (7 oz/1⅓ cups) plain (all-purpose) flour
1 tablespoon Old Bay Seasoning

To serve
white onion, cut into thin rings
white bread slices
American mustard
sliced pickles (gherkins)
Ranch Dressing (see page 81), optional

For the seasoning, combine the chilli powder and salt in a small bowl. Set aside.

To make the flour mix, combine the flour and seasoning in another bowl.

Pat the fish fillets dry and check again that all the bones are removed, then dust with the flour mix on both sides.

Whisk the egg, buttermilk, salt and white pepper together in a bowl. Place the cornmeal in a separate bowl.

Dip each fish fillet first into the buttermilk mixture and then into the cornmeal to coat evenly. Arrange the coated fillets on a tray and set aside in the fridge for 1 hour.

When ready to cook, half-fill a heavy-based skillet, saucepan or deep-fryer with oil and heat to 180°C (350°F). Carefully lower the fish pieces into the hot oil and fry for 2–3 minutes until golden and cooked through, being careful not to let the oil get any hotter as you will risk burning the cornmeal. Drain on paper towel and dust with the seasoning mix.

To serve, pile some finely sliced onion rings onto bread slices, lay the fish fillets on top and finish things off with some mustard, sliced pickles and ranch dressing, if you like (it's optional, but it makes this sandwich a whole lot better).

HOT FRIED OYSTERS

I love oysters and these ones are like little antidepressants—for some reason or another they just make me happy (like, real happy).

Ok, let's be honest, if you're not a professional chef—and I mean a good professional chef—oysters are not to be shucked by you. There is more skill in shucking an oyster than you think, and if you reckon you already know, there is a good chance you don't. The trickiest bit is being careful not to grind and break the shell or pierce the body of the oyster, and the second trickiest bit is not slipping and putting an oyster knife through your hand, destroying the oyster in the process. Trust me, the latter really hurts, so promise me you'll just get the fishmonger to shuck them for you.

Serves 2–6

24 oysters, shucked
200 g (7 oz) cornflour (cornstarch), plus extra if needed
50 g (1¾ oz/⅓ cup) plain (all-purpose) flour
1 tablespoon Old Bay Seasoning
pinch of white pepper
250 ml (8½ fl oz/1 cup) really cold soda water, plus extra if needed
peanut or canola oil, for deep-frying
salt flakes
cayenne pepper, to serve
Ranch Dressing (see page 81), to serve

Very gently drain the oysters as best you can, reserving the brine and removing the oyster meat from the shell. Set the shells and oyster meat aside.

Whisk the flours, seasoning and pepper together in a bowl, then pass the mixture through a fine sieve.

Working one oyster at a time, carefully coat the oysters in the flour mix, then lay them out on a tray lined with baking paper. Reserving the remaining flour mix, transfer the tray to the fridge and leave to sit for 2–3 hours (or just as long as you can wait).

Combine the oyster brine with the soda water in a separate bowl.

In a steady stream, whisk the liquid mixture into the remaining flour mix, using just enough to make a runny paste-like batter. (The batter should be thick enough to just coat the back of a spoon—if it's too runny add a little more cornflour, if too stiff, a little more soda water. Don't panic.)

Half-fill a heavy-based skillet, saucepan or deep-fryer with oil and heat to 180°C (350°F).

Working quickly and carefully, dip the oysters into the batter and let the excess batter drain off before lowering them into the hot oil. Cook for 30 seconds or so until golden brown and crisp, making sure you keep the oysters moving around in the oil so they don't stick to the bottom or each other.

Remove the oysters from the hot oil and drain on paper towel, then return them to the shells, season well with salt and dust with cayenne pepper. Serve immediately with loads of ranch on the side.

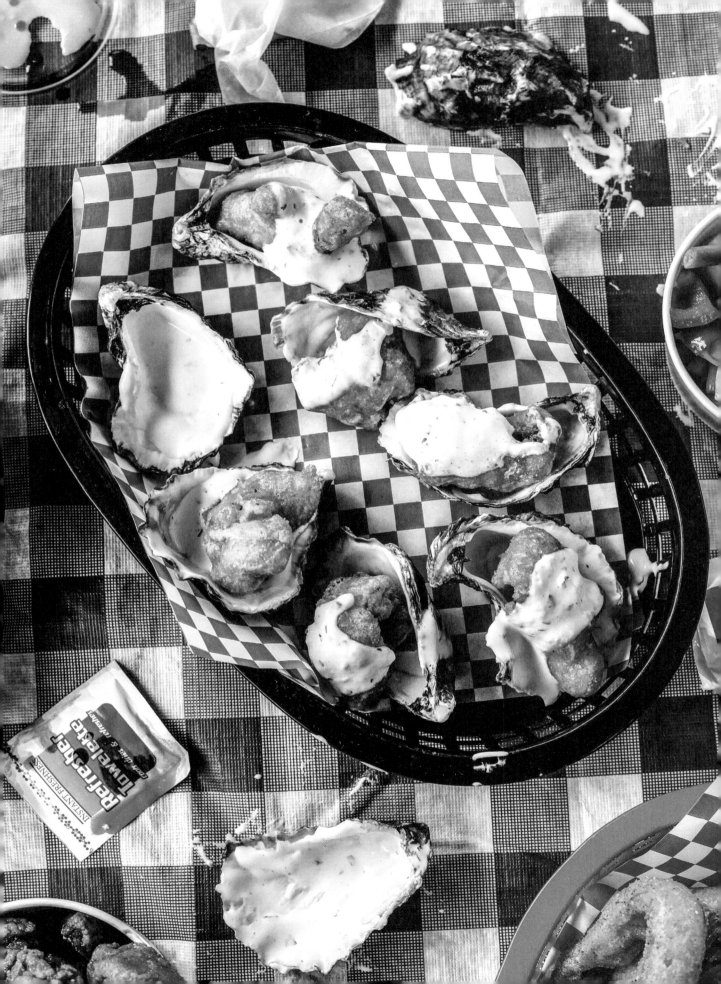

CHOW CHOW

Chow Chow. A kinda relish, kinda pickle. One thing it is, though, is addictive. It has endless uses and tastes great whether served with oysters, as a side for roast chicken or on a cheese sandwich. There really are no rules, just go for it.

Set some time aside to make this—it's not a quick one, more a once-a-year thing, and it makes a lot, though it will keep forever in sterilised sealed jars. Early spring is the best time to attempt this recipe, with the end of the winter produce still around and all the new season stuff coming through. And don't feel tied to the vegetables listed below either—feel free to use whatever you like or have access to.

Makes about 7 kg (15 lb 7 oz)

1 kg (2 lb 3 oz) firm green tomatoes
1 kg (2 lb 3 oz) green beans
500 g (1 lb 2 oz) savoy cabbage
1 kg (2 lb 3 oz) cauliflower florets
1 kg (2 lb 3 oz) carrots
1 kg (2 lb 3 oz) celery
1 kg (2 lb 3 oz) capsicums (a mix of red and green)
1 kg (2 lb 3 oz) white onions
200 g (7 oz) rock salt
2 litres (68 fl oz/8 cups) warm water

Pickling liquid
1.5 kg (3 lb 5 oz) sugar
1.5 litres (51 fl oz/6 cups) apple-cider vinegar
900 ml (30½ fl oz) water
1 tablespoon coriander seeds
1 tablespoon whole allspice berries
1 tablespoon black peppercorns
1 tablespoon dill seeds
1 tablespoon whole cloves
8 dried bay leaves
2 tablespoon yellow mustard seeds
1 tablespoon celery seeds
1 tablespoon fennel seeds
1 tablespoon cumin seeds

Cut the vegetables into roughly similar-sized pieces. (Different shapes is fine, and these can be as neat or as roughly chopped as you like.)

Add the rock salt and water to a large bowl or clean bucket and stir to dissolve. Leave to cool to room temperature, then add the cut vegetables and leave at room temperature for 12 hours or overnight.

The next day, drain the vegetables and rinse well with fresh water. Set aside.

Combine all the pickling liquid ingredients in a very large saucepan or stockpot and bring to the boil. Lower the heat, add the vegetables and simmer for 5 minutes, then turn off the heat and leave to cool until warm but not hot. Ladle the warm chow chow into sterilised mason jars (see page 49) or suitable non-reactive airtight containers and keep in the pantry or refrigerator until needed. If everything is clean and sealed well the chow chow will last for over a year.

PICKLED ONION RINGS

These can be skillet or deep-fried, and pickling the onions beforehand takes them to another level. It's a bit of a process to be planned out before, but it's worth it. Choose medium-sized firm brown onions—they will be the sweetest and make the best-sized rings—and any you don't get through you can store in the pickling liquid, ready for the next time you need an onion ring fix.

Any beer will do for this recipe. I prefer a good old domestic beer—one that tastes like a beer—but if you are a hoppy craft drinker, by all means make the batter with your fifteen-dollar can.

Serves 6–8 as a side

2 kg (4 lb 6 oz) brown onions
vegetable oil or lard, for frying
plain (all-purpose) flour, for dusting
sea salt and cracked black pepper

Pickling liquid
3 litres (101 fl oz/12 cups) apple-cider vinegar
1 litre (34 fl oz/4 cups) water
600 g (1 lb 5 oz) sugar
1 tablespoon whole cloves
15 black peppercorns
1 cinnamon stick
1 star anise
1 tablespoon cardamom pods
6 fresh bay leaves

Batter
750 ml (25½ fl oz/3 cups) beer, plus extra if needed
220 g (8 oz/1½ cups) plain (all-purpose) flour,
 plus extra if needed
½ teaspoon ground cloves
½ teaspoon ground white pepper
a good splash of hot sauce (see page 80 for homemade)

For the pickling liquid, combine all the ingredients in a large saucepan and gently bring to the boil, then lower the heat and simmer for 20 minutes. Set aside to cool to blood temperature (stick your finger in it—if the liquid is neither hot nor cold, then you are there).

Peel the onions and cut them in half widthways and then in half again, then separate the layers out to create 4 layers of rings.

Add the onions to the pan with the pickling liquid and bring to a gentle boil, then turn off the heat and leave to sit for 30 minutes.

While the onions are pickling, make the batter. Whisk together all the ingredients in a bowl to form a smooth batter, adding more beer if the batter is a little too thick or more flour if too runny until you get to the right consistency.

Half-fill a heavy-based skillet, saucepan or deep-fryer with oil or lard and heat to 180°C (350°F).

Working quickly, take the onion pieces from the pickling liquid (reserving the liquid for use another time, or to store leftover onions), dust them in a little flour, then dip them into the batter. Remove the rings from the batter with a fork, lower them straight into the hot fat and fry for 3–4 minutes, until golden and crisp, turning them every 30 seconds or so to prevent the batter sticking or burning. (A burnt onion ring is, as you can imagine, very unpleasant and you will have wasted all of your time, so pay attention here and really watch the colour of the batter.)

Remove the cooked onion rings from the hot fat, drain on paper towel and season with salt and some cracked pepper, if you like (I do, but it's not for everyone). Serve.

HOT FRIED CHICKEN GIBLETS

These little bites of heart, gizzard and liver tossed in chilli-flecked seasoned flour might not sound like they're for you, but give them a try and I promise you'll be coming back for more.

Serves 4–6

500 g (1 lb 2 oz) chicken giblets
200 ml (7 oz) buttermilk
2 tablespoons hot sauce (see page 80 for homemade)
pinch of salt flakes
150 g (5½ oz/1 cup) plain (all-purpose) flour
50 g (1¾ oz) potato starch
2 tablespoons Old Bay Seasoning
200 ml (7 fl oz) cottonseed or vegetable oil
1 teaspoon chilli powder
½ teaspoon smoked paprika

Wash the giblets under cold running water for 5 minutes. Drain and pat dry with paper towel.

In a bowl, combine the buttermilk, hot sauce and salt. Add the giblets and leave to marinate for 15 minutes.

Combine the flour, potato starch and seasoning in a paper or zip-lock bag.

Drain the giblets and add them to the bag, then close the bag tightly and shake well for 2 minutes, or until the flour mix has clumped together and stuck to the giblets, coating them all over. Leave to sit for 10 minutes.

Heat the oil in a shallow frying pan to 170°C (340°F). Add the giblets to the hot oil and fry for 2–3 minutes until golden brown, using a spoon to baste if needed. Drain on paper towel.

Combine the chilli powder and smoked paprika in a small bowl. Dust the giblets with the mixture and serve immediately.

SWEET HORSERADISH SAUCE

A quick, versatile sauce that adds a little fire and sweetness to any dish.

Serves 4–6

75 g (2¾ oz) horseradish cream
1 teaspoon onion powder
1 teaspoon garlic powder
300 g (10½ oz) whole-egg mayonnaise
1 tablespoon hot sauce (see page 80 for homemade)
1 teaspoon worcestershire sauce
110 g (4 oz) pickle (gherkin) relish
sea salt and ground black pepper

Add all the ingredients except the pickle relish to a food processor and blitz together until smooth. Fold through the relish and season to taste with salt and pepper. Store in the fridge until needed (it will keep for up to 7 days).

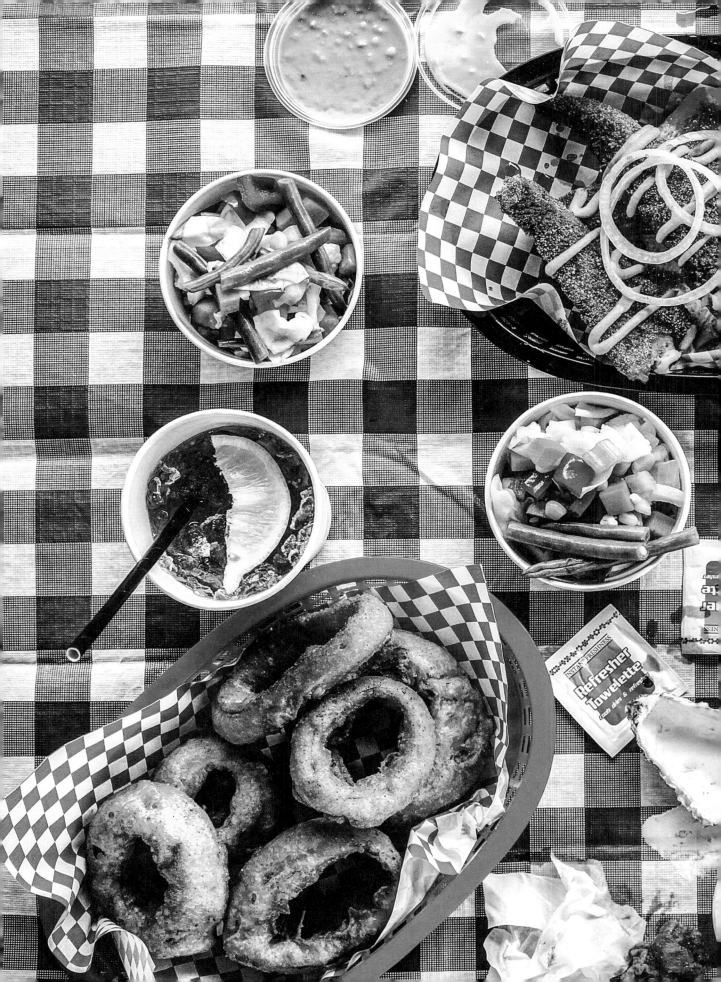

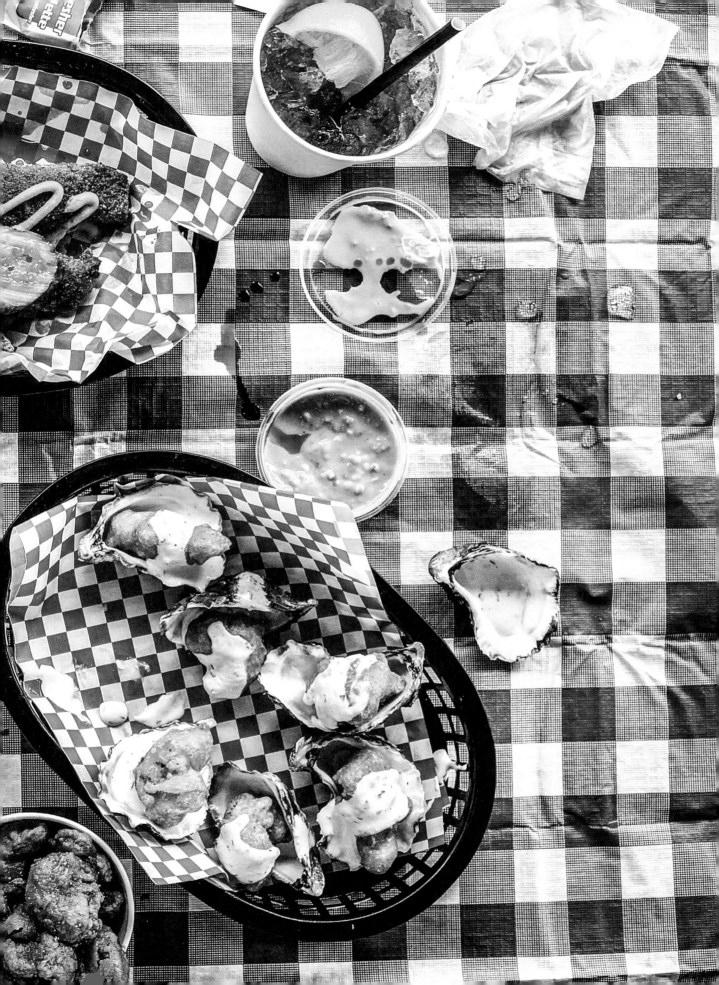

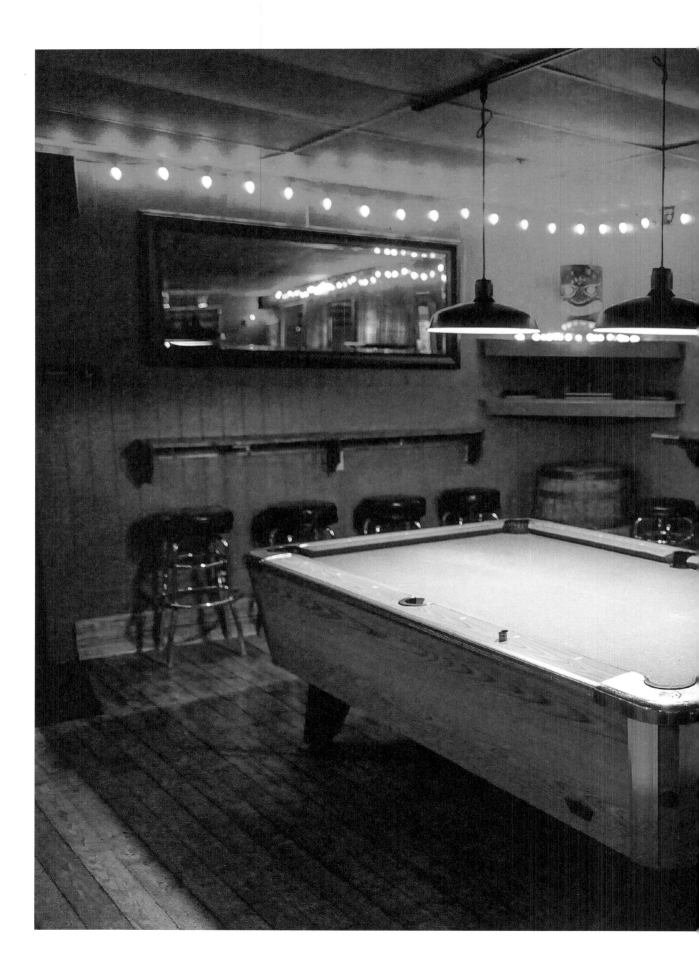

I need to show you something. Over on the west side, just by Vanderbilt, tucked behind the high-rises of Music Row.

That area is all changed now, by the way.

Gone are the songwriter bars that housed some of the best in the business, the oases from the studios where writers penned hit after hit, these places have all been bought up and developed, levelled in the name of progress to make way for apartments and carparks and offices to house the number crunchers and contract writers.

Even Bobby's Idle Hour Tavern, the last of its kind, has been given a death warrant, as developers make plans to level another piece of Nashville history.

I wonder how long it will be before they come for Bolton's? Their bunker may not look like much, but it's sitting on prime real estate.

THE WEST SIDE

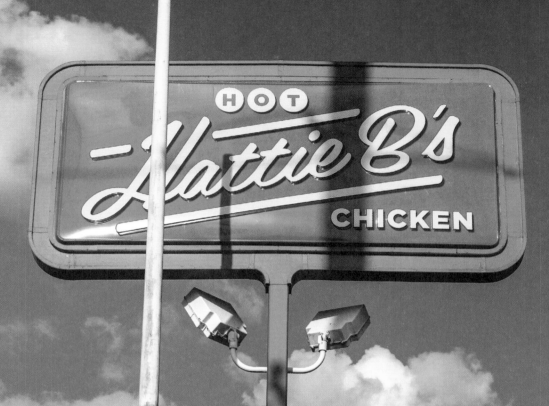

HOT

Hattie B's

CHICKEN

H B D
CHARLOTTE
5 YRS

Hattie B's

HOT C

NO PARKING
HERE TO
CORNER

CLAIM CAR
PREIGHTLINER DRIVE
862-7800

I like a little chaos, especially for what we do. Chaos suits us, the chicken slingers—outlaws of the fryers, renegades of the spicy bird.

We need the energy and the chaotic potential.

It feels a little more natural to cook in chaos, among the noise of the neighbourhood. People eating with their hands, getting down and dirty with the spices and the flour, making a mess, tearing crispy chicken from the bone, dunking bits of chicken into hot oil, dripping in sauce, yelling orders—it makes sense. So over here, on this side of town, it just seems a little boring. Safer. Cleaner. Gentrified.

Regardless of how I feel about it now, though, this was still my first, and like they always say—you never forget your first time. It was no different for me. I was hooked. It was love at first bite.

Small dark meat—hot—fries, pickles and blue cheese. That was it, my very first order of hot chicken. Midtown July 14th, 2013 at 7.32 pm. Hattie B's was, and will forever be, my first.

The night I fell in love. Nashville Hot Chicken love.

I was sitting third table on the left, by the window. I can still picture it. It came out glowing orange, glistening with promise, and my anticipation was higher than I can ever remember it being for a plate of fried chicken.

In an instant the smell of hot chilli powder and paprika filled my lungs, making me cough and splutter. Embarrassing. Then the sneezing started, and I had to wipe my nose every few seconds. Inevitably, I touched my eyes, wiped my lips and, well, we all know how that goes. And all this before I even took the first bite.

Once I composed myself and gathered my thoughts, salivating in anticipation, I took that bite—the game changer, the awakening—just like at some point I'm sure Bolton would have done when he joined Thornton as a cook, and just as Thornton did when he woke from his drunken slumber to eat his girlfriend's chilli-doused revenge.

Hot chicken had me transfixed, and something I didn't quite understand had happened. In a single moment everything had changed.

I would try it all. Every combination of cuts, heats and sides. Tenders—mild—with sides of southern greens and pimento mac 'n' cheese. Dark meat—hot—with fries, blue cheese and ranch (sometimes with a tender—damn hot—too). White meat—southern, so I could taste those spices—with sides of black-eyed pea salad and extra pickles.

Or I'd get an extra tender, extra wing coated dark with "Shut The Cluck Up"—the hottest of hot spices. The novice I was would regret that immediately: it sent my stomach into fits of rage, fighting for relief any way it could.

No matter what I chose it was always cooked to order and always seasoned to perfection. This was before the lines, before the hype, before it all got out of control. (I should also note this was before I discovered Prince's, before I had ever been to Bolton's, before I knew any better.)

I heard someone once, at a table next to me, telling a friend over a piece of white meat and sweet tea that these guys took hot chicken out of the neighbourhood and made it safe for this side of town to eat. That they gentriFRIED it.

I know, I know. It's a bad joke, but I can see you smiling. And it's true, they opened on the 'safe side' of town. This isn't a strip mall known for drug deals and prostitution, like where Prince's currently resides, it's not a concrete bunker on the east side surrounded by drunken sidewalk buskers like at Bolton's. Nope, this is Vanderbilt country—khaki shorts and pleated chinos.

I don't want you to take this the wrong way or get the wrong idea. It was good here, the food, the chicken. After one too many late-night shifts at the bar, rolling in for a serve of hot wings and a cold beer was the highlight of my day. I could walk straight in, order and sit down with a cold beer. I gotta tell you, that combo on a hot Nashville night, well, it was damn near perfect.

And then the world came knocking.

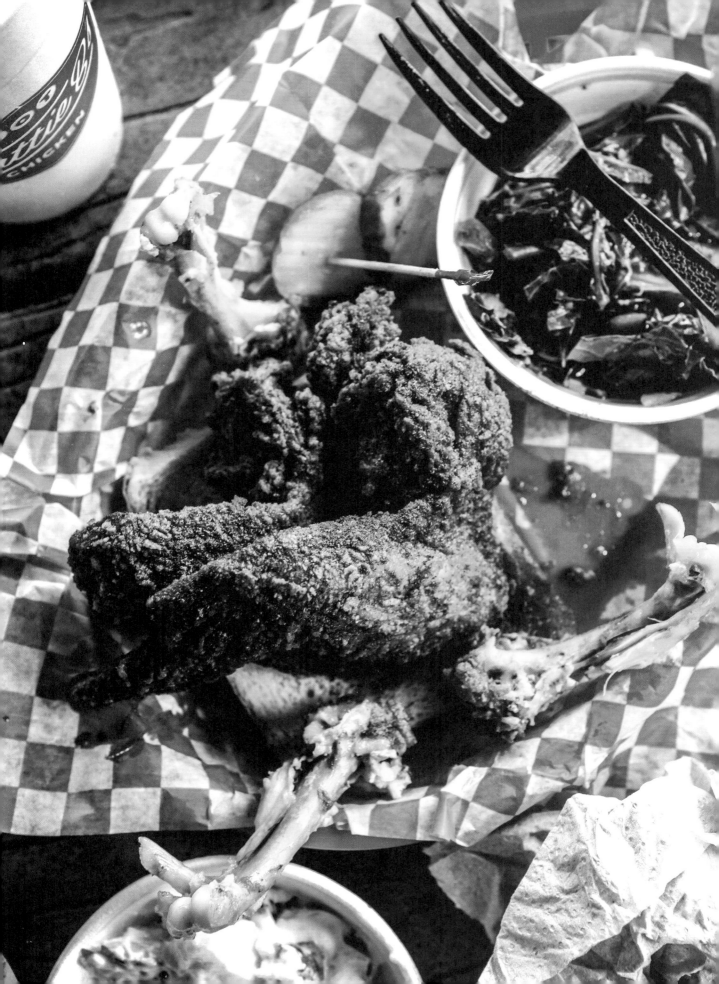

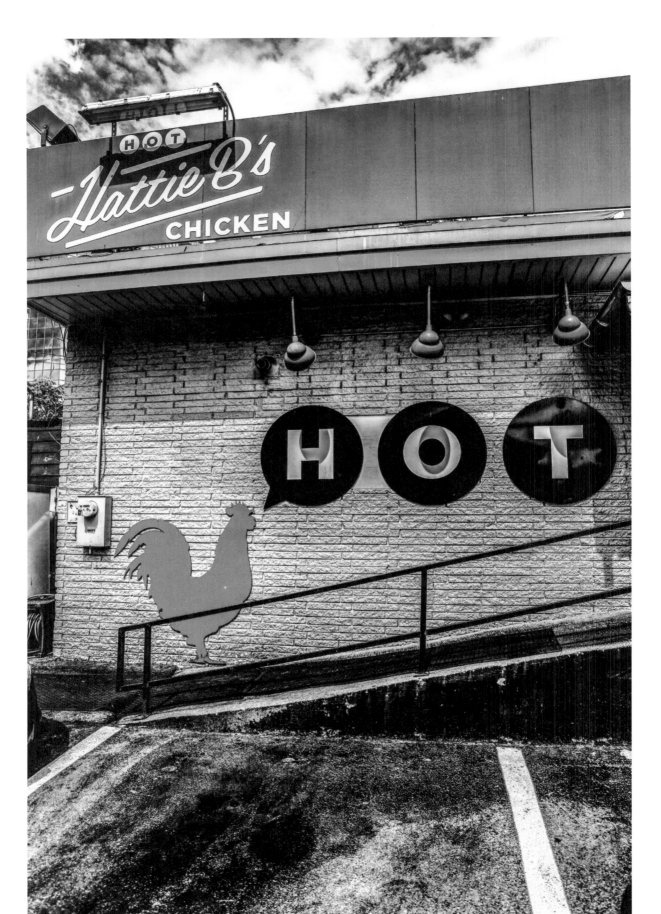

There's a line now just to get in to order that must be at least an hour and a half long. It's a hell of a wait in the southern sun.

It felt like it was overnight, their success coming seemingly out of nowhere. In an instant Hattie B's became the poster child for a new Nashville, a city emerging from a decades-long hangover from the glory days when outlaw country ruled the airwaves.

Whether they knew it or not, they held the Golden Ticket. Hattie B's would be the ones to take the humble dish of hot chicken from the neighbourhoods to heights no one could have ever dreamed possible.

It really was as quick as that—overnight they were in every publication across America. Every food writer and magazine wanted the inside scoop, every half-baked blogger came knocking, wanting to know the secret to Hattie's success. And always with the same tired questions that only food reporters can ask. How did the chef come up with the recipe? What's the secret family recipe?

They started to appear on the Food Network, as well as in food challenges daring the nation to eat the hottest of hot. Shut the Cluck Up was the name on everybody's lips from the East Coast to the West. Celebrities in town would drive by for a taste of the chicken and a photo opportunity, a way to entice a new generation of Instagram fans. And Hattie B's knew how to play it, how to capitalise, and quickly opened their second, third and fourth stores.

It seemed like everywhere you turned, there they were. Hattie B's, the flag-bearers, quickly staking claim to the dish that was sweeping the nation. For the others, trust me, I know how that hurts to hear, someone laying claim, but they always paid their dues. They never tried to rewrite the history, there was no ownership, just a celebration of a dish so uniquely part of the city they lived in. It was progress held safely in the hands of Hattie B's.

Calling:

Number 53: wings—medium—side of slaw and pimento mac 'n' cheese. *Number 53*: small dark meat—damn hot—fries and beans. *Number 53*: half bird—hot—southern greens and red-skin potato salad. *Number 53*: three jumbo tenders—SHUT THE CLUCK UP—black-eyed pea salad, extra pickle, honey mustard and blue cheese.

I went and ordered Shut the Cluck Up. I wouldn't have been able to live with myself if I didn't. Everyone who comes here has to try it at least once, and I had to relive it—it's a Nashville rite of passage. I knew when I ordered it I'd probably regret it, either immediately or at some point in the early hours of tomorrow morning, but at least I had the good sense to get tenders. I know it'll be all-out war on my stomach, which has been under siege ever since we got into town—a covert assault of chillies, spices, fats, alcohol and chicken.

You see, the spice here is a bit different to back at Bolton's. It's more of a builder and a creeper, different to the sledgehammer Agent Orange that graces Bolton's bird. It's more in the Prince's style, the spices mixed in with the cooking fat to make a paste that coats the bird a hellish hue. Here, at first, you shrug it off, as if it ain't so bad. You think—is that all they've got? Where's the heat? And on the second, third and fourth bite, you're still thinking, I got this, Shut the Cluck Up ain't so bad. But then, out of nowhere, it hits from the fiery depths, it grabs a hold of your throat, your lips start to tingle a little, you start to sniffle—just short, little ones at first, or maybe a cough here and there—then you start taking longer drinks from your 40 oz, thinking maybe no one will notice. Then you sneeze once or twice, desperately trying to hold it in, not wanting to embarrass yourself, but it never works and now your eyes start to water, you stop taking bites in an effort to cool your lips and mouth, and all of a sudden you're under attack, throat burning, eyes watering, nose running. It's on—an all-out attack. And it has, indeed, shut you the cluck up.

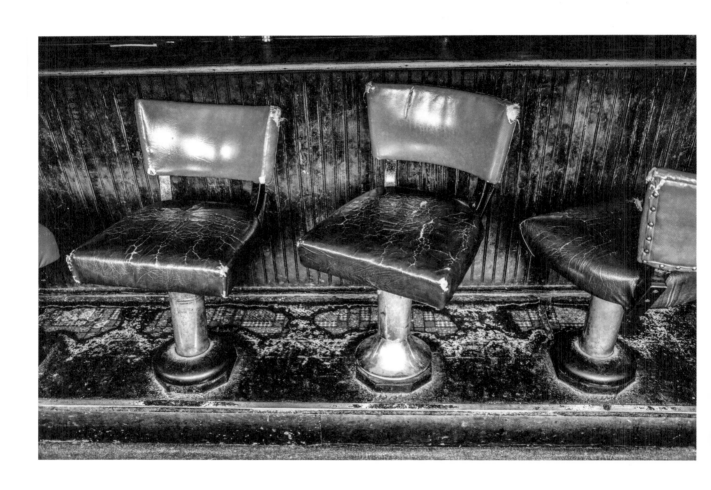

Well, it used to be like that, anyway. Eating it here, eating it now, it's nothing more than mild and quite pasty—only seasoned on one side of the cut. Something tells me they have mellowed the attack to satisfy the line that forms out the front these days, trying to keep it approachable for the masses.

Sadly, the crunch has become a victim of their success as well. You can tell it's twice-fried, and it's soaked up a lot of oil between the first and second cook. The flesh is dry and a bit too dense, the breading more soft than crunch.

City rumour has it that Hattie B's cook a tonne of chicken a day here. I can't say if that's true or not—it might just be town gossip—but I'm guessing, based on the speed our food came out, that there's a lot of chicken back there being held, waiting to fill the orders rushing in, waiting for a swift shake of the required heat before sending it out to the front. It wouldn't surprise me because that line won't let up, and it's growing by the hour. It must be relentless in that kitchen. The nonstop frying, shaking and boxing and traying of orders. The constant line of people. And no reprieve from the heat. That alone could send a fry cook crazy.

But even now, sitting on the front porch of Hattie B's, sweating in the midday heat, brings back so many good memories. Days spent eating and drinking as a newcomer to the city, using any excuse I could to get there. It was a cure-all for week-long benders, the place for a late-night snack, the scene of many first dates or whatever reason I could muster. I was always up for it and ready to go at a moment's notice. A Hattie's run? I'm in.

But then one day it all changed. After a lunch of my go-to hot wings, slaw, fries and a 40 oz, I moved down the road and settled in at Robert's Western World—the last of the great honky-tonk bars left on Broadway—day-drinking the afternoon sun away and listening to the band play Hank Williams and Buck Owens. A well-dressed stranger sitting next to me at the bar noticed my stained fingers and strange accent and asked if I was new to town. Then he asked me if I'd been to Prince's. Apologetically, I said I hadn't, but I had just finished lunch at Hattie B's and clearly hadn't washed my hands as well as I should have and, also, what's Prince's?

He introduced himself, apologised that he had to run, that he had a suit to finish stitching, knocked back the rest of his Budweiser and waltzed out, but not before passing on the warmly delivered threat of "That ain't the chicken you need to be eatin'; you haven't eaten our hot chicken till you've been to the Temple, out east."

I wrote the name on a bar napkin, Prince's Hot Chicken, and put it in my pocket for safekeeping.

So that's how I found out that deep in the neighbourhood, on a strip mall next to a nail salon, there was a place that had been frying chicken for generations and was still frying to this day, unchanged, using the same old recipe it always had, from back when Thornton was frying in Hell's Half Acre with Bolton by his side. It was ground zero for hot chicken lovers, and it was right here in the neighbourhoods of Nashville.

Late one Saturday night I took a less than sober ride out east with a friend and we ended up at André's place—Prince's Hot Chicken.

That first order of Prince's chicken changed it all. That's when I knew I was eating something truly unique and special. A window with a hand-painted sign and what looked like bullet holes at shoulder height; an empty bottle of moscato strewn on the sidewalk next to a discarded condom wrapper; a rat trap and a bottle of prescription pills and a straw. It looked like a crime scene—or someone's idea of a good night out.

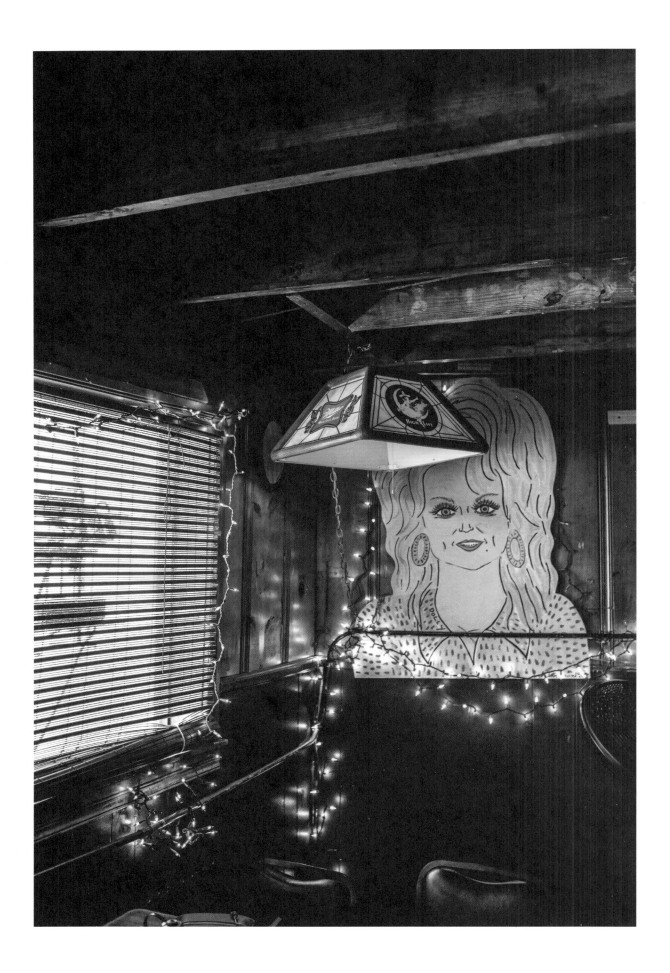

But just past this were the doors, the gateway to Mecca. I walked through, pushing them open harder than they probably needed, and the whole room stopped to see what the commotion was. I excused myself, squeezed past the man with a gun moonlighting as security, and nervously ordered my first cut of Prince's chicken. Waited patiently for forty minutes. Snapped a photo, time stamped 1:13 am, and then I took my first bite.

That's when it all made sense.

I knew right there and then that I'd found the real deal, sitting in a dining room full of late-night happy faces, laughing, talking, smiling, happily tearing into plates of chicken and sides.

The crunch of the chicken was like no other, the heat, the cook, the temperature all seemingly perfect. Nose running, eyes watering, lips burning, face numb—instantly all was well with the world. I was happy. For the first time, I was experiencing the true virtue of a good piece of chicken fried.

Hands raised, I proclaimed I had fallen head over heels in love, once again.

I made a semi-drunken pact that night to try to figure out how it was done. I needed to know how to make something so damn delicious, and I felt I was going mad not knowing the secrets of what I was eating. I needed to see if I could unlock the mystery that surrounded this fiery bird.

Sure, I'd had fried chicken before, I'd even cooked it at times. I'd eaten chicken fried and doused in whole dried chillies in Hong Kong, and Korean fried dipped in a sweet fermented chilli sauce. Hell, I even think at some point in my hungover past my flatmate put sriracha on cold KFC as a survival attempt to sweat out the evils from the night before.

But one thing I did know was that none of that was anything like what I was eating now in Nashville.

I had to know how it was done, and what made it so goddamn delicious. What was on it? I needed every detail, all the tricks. If I could only get out back into that kitchen, spend a little time with the cooks, ask the right questions, watch them work, at least then I would have a starting point. But I knew it was off limits as soon as I started to ask. "No one allowed in the kitchen but the cooks" was the blunt reply from André. For the record, Bolton's nephew gave me the same answer one late night as I ate a plate of wings: "Son, no prying eyes in the kitchen."

And I get that. It's a smart move, and I'm sure I'm not the first person to ask. There are things that we—as cooks—want to protect, things we want kept guarded. Perhaps it's a method of breading that has been passed down through grandmothers and fathers, aunts and uncles—a method so steeped in family knowledge it can't possibly be recreated. Maybe it's a question of which shortenings fry the best chicken and on what day it's at its best. The third? Or fourth? There were so many questions I had and as a cook I wanted all the nuances explained to me. I assumed nothing. I zeroed in and started from the start.

I remember thinking, I'll just keep eating until I figure this out as best I can.

But first things first.
What fucking flour do I even use?

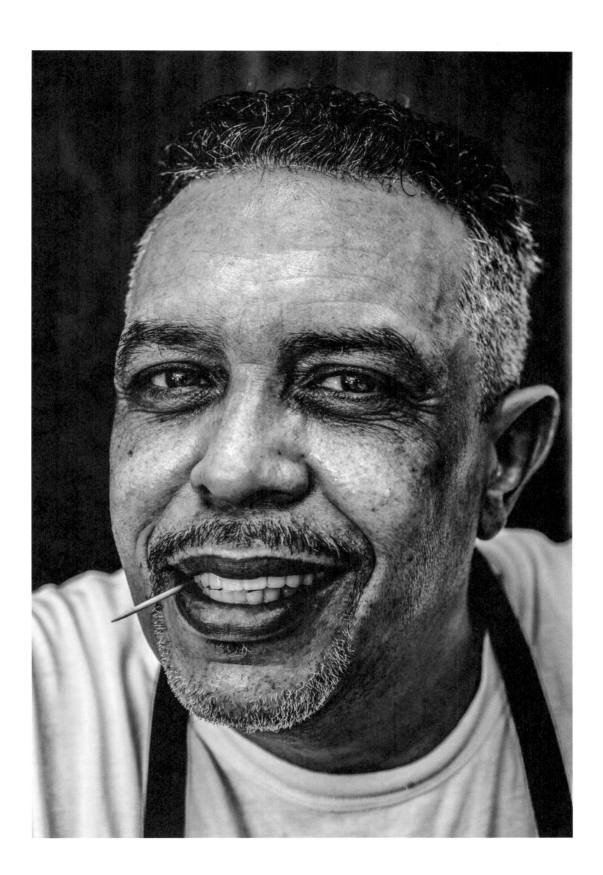

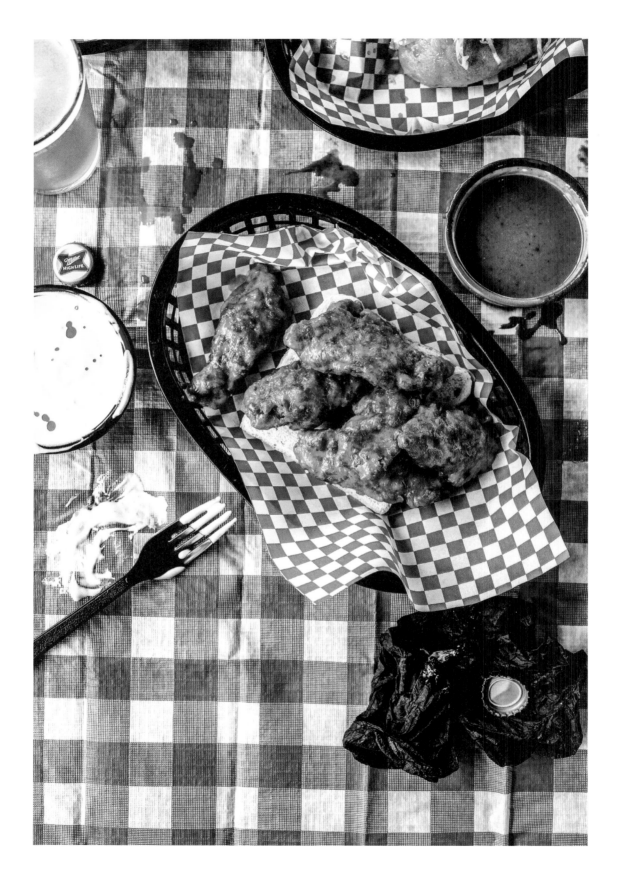

HOT SAUCE CHICKEN RIBS

Chicken ribs are more of a butchering trick than anything, really—they're just another way to cut down the bone-in chicken breast. Take note: the blue cheese sauce for dipping here is non-negotiable.

Serves 4–6

250 g (9 oz/¾ cup) rock salt
2.5 litres (85 fl oz/10 cups) warm water
1 kg (2 lb 3 oz) chicken ribs
250 g (9 oz/1²/₃ cups) plain (all-purpose) flour
1 teaspoon dried oregano
1 teaspoon cracked black pepper
200 g (7 oz) butter
200 ml (7 fl oz) hot sauce (see page 80 for homemade)
vegetable oil, for frying
Blue Cheese Sauce (see page 191), to serve

Add the rock salt to the water in a large bowl and stir together to dissolve. Lower the chicken ribs into the brine and leave for 1 hour. Drain and pat dry with paper towel.

Mix the flour, oregano and black pepper together in another large bowl. Add the brined chicken ribs and toss to coat. Set aside.

Melt the butter in a small saucepan over a low heat, then whisk together with the hot sauce until combined and emulsified. Keep warm.

Half-fill a heavy-based skillet, saucepan or deep-fryer with oil and heat to 185°C (365°F).

Working in batches and being careful not to overload the pan (which will reduce the heat of the oil and make your ribs oily), lower the chicken ribs into the hot oil and fry until crisp and golden brown, about 6 minutes.

Remove the ribs from the oil, drain on paper towel and season well with salt, then toss them in the hot sauce/butter combo until really well coated. Serve with blue cheese sauce.

HOT CRAYFISH ROLL

I grew up on the coastline of southern Australia famous for its rock lobster (AKA crayfish), so it made sense for me to include this take on the famous New England lobster roll here—held high in the spirit of Nashville Hot Chicken, of course.

Serves 4

1 × 600 g (1 lb 5 oz) crayfish
pinch of salt flakes
4 brioche buns
80 g (2¾ oz) butter, melted
2 baby cos lettuces, leaves separated and washed

Sauce
250 g (9 oz/1 cup) whole-egg mayonnaise
juice of ½ lemon
1 tablespoon apple-cider vinegar
2 teaspoons dijon mustard
1 teaspoon tomato sauce (ketchup)
120 ml (4 fl oz/½ cup) grapeseed oil
½ teaspoon chilli powder
pinch of salt, plus extra if needed
½ bunch of dill, finely chopped

Dressing
100 g (3 oz) butter
100 ml (3½ fl oz) olive oil
1 teaspoon smoked paprika
1 teaspoon cayenne pepper

Bring a large saucepan of salted water to the boil. Carefully add the crayfish to the pan and boil for 8 minutes, then turn off the heat, cover with the lid and leave to sit for a further 2 minutes. Remove the crayfish from the pan and plunge it into a bowl of iced water to stop the cooking process.

To make the sauce, whisk together the mayonnaise, lemon juice, apple-cider vinegar, mustard, tomato sauce, grapeseed oil and chilli powder in a bowl. Add a pinch or so of salt to taste, then fold through the dill. Set aside.

For the dressing, melt the butter and oil together in a small saucepan over a low heat, then add the paprika and cayenne and whisk together to combine. Keep warm.

Remove the crayfish from the iced water and cut off the tail. Cut lengthways down the tail and break away the shell from the meat, then dice the meat into rough pieces. Transfer the diced meat to a bowl, sprinkle over the salt, spoon over the sauce and mix everything together well.

Split the brioche buns down the middle and brush the insides with the melted butter. Get a skillet or frying pan nicely hot, then add to the pan buttered side down and leave for a few seconds until lightly charred.

While the bun halves are still warm, bring them together and pile them high with the baby cos leaves and the sauced crayfish meat. Spoon over the buttery dressing and serve.

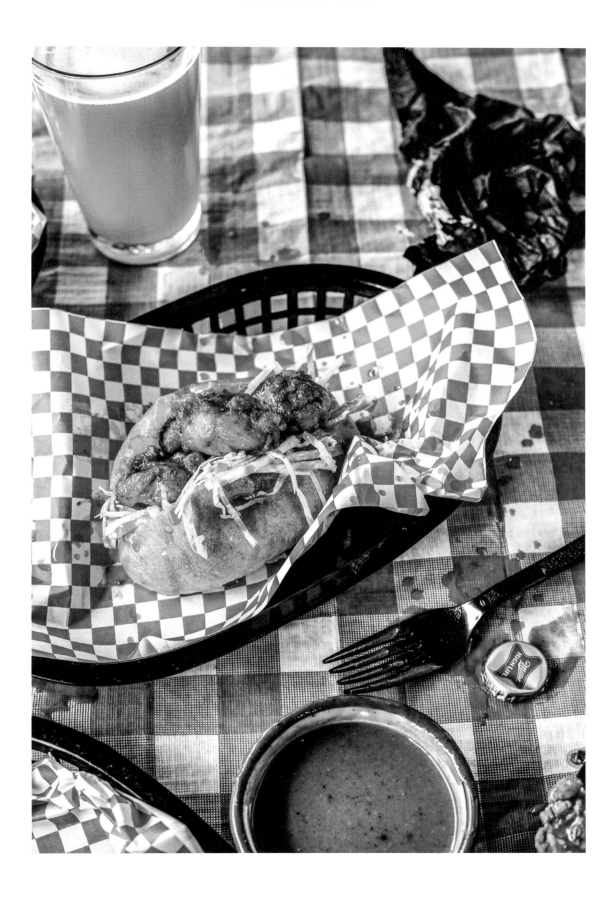

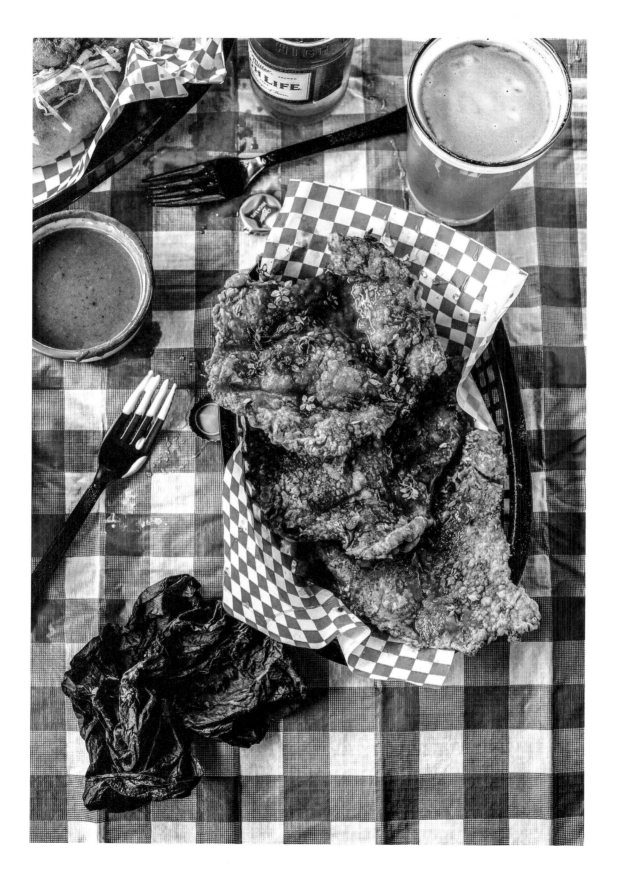

FRIED CHICKEN SKINS

Chicken skins aren't easy to come across but they're definitely worth the effort to find. Ask your butcher to save some for you. The amount of honey and hot sauce you use to cover these skins depends on how sweet and hot you want them to be—it's up to you—and be aware that this recipe needs starting the day before eating.

Serves 4

250 g (9 oz/¾ cup) rock salt
2.5 litres (85 fl oz/10 cups) warm water
400 g (14 oz) chicken skins
vegetable oil or lard, for frying
sea salt
½ bunch of lemon thyme, leaves picked
honey, to serve
hot sauce (see page 80 for homemade), to serve

Spiced flour mix
2 tablespoons dried sage
2 tablespoons black peppercorns
100 g (3½ oz) table salt
3 tablespoons coriander seeds
2½ tablespoons whole cloves
400 g (14 oz/2²/₃ cups) plain (all-purpose) flour

Add the rock salt to the water in a large bowl and stir together to dissolve. Lower the chicken skins into the brine in a large bowl and leave for 40 minutes. Drain the skins well and lay them flat on a tray.

For the spiced flour mix, add all the ingredients to a bowl and mix together well.

Transfer the spiced flour mix to a sieve and use it to dust both sides of the chicken skins to cover all over. Using your hands, press the flour into the skins. Reserving any leftover flour mix, place an even weight (a few tins of beans will do) on top of the chicken skins, then transfer the lot to the fridge and leave overnight.

The next day, remove the skins from the fridge and leave them for 20 minutes to come to room temperature.

Half-fill a heavy-based skillet, saucepan or deep-fryer with oil or lard and heat to 180°C (350°F).

Lightly dust the skins with the reserved flour, then carefully lower them into the hot fat and fry for 4 minutes, turning halfway through cooking, until golden and crispy.

Remove the skins from the fat, drain on paper towel and season with salt. Scatter over the thyme leaves and drizzle with honey and hot sauce all over. Serve.

HAND PIES

I don't have much of a sweet tooth, so these are perfect. You can make them any size you like, but the idea behind them is that, once cooked and cooled a little, you can hold them in your hand and eat them on the run. You can fill these with anything you like, really—fresh berries, stewed fruit, tinned fruit—and they can also be easily adapted to make them work for savoury fillings too, just omit the sugar from the pastry.

The pastry here needs to be made the day before. And if you can't get hold of cake flour, just sift 1 tablespoon of cornflour with the same quantity of plain (all-purpose) flour, less a tablespoon.

Makes 8–10

600 g (1 lb 5 oz) seasonal fruit such as blueberries or strawberries, cut into small chunks
vegetable oil or lard, for frying
icing (confectioners') sugar, to serve

Pastry
560 g (1 lb 4 oz) unsalted butter, chilled
175 g (6 oz) lard, chilled
1.3 kg (2 lb 14 oz) cake flour
3 tablespoons sugar
1½ tablespoons salt
465 ml (15½ fl oz) ice-cold water

To make the pastry, cut the butter and lard into 1 cm (½ in) cubes and place in the freezer for 10 minutes, or until firm.

Combine the flour, sugar and salt in a bowl. Add half the butter and lard cubes and toss to coat, then transfer the mixture to the bowl of an electric mixer with the beater attachment added and beat together on medium speed, adding the remaining butter and lard as you go, until the mixture resembles a coarse meal. Add the cold water and beat again slowly until it forms a rough dough, then remove from the mixer, wrap the dough in plastic wrap and refrigerate overnight.

The next day, roll the dough out to a thickness of 4 mm (¼ in) and cut it into 13 cm (5 in) circles.

Cover half of each pastry circle with seasonal fruit, leaving a small border around the edge, then fold the pastry over to cover the fruit and press along the edges, pinching and folding to seal. Transfer the pies to the freezer for 20 minutes to firm up.

When ready to cook, half-fill a heavy-based skillet, saucepan or deep-fryer with oil or lard and heat to 180°C (350°F). Working in batches of two to three, carefully lower the pies into the hot fat, shaking the pan gently so they don't stick together, and cook for 10 minutes, turning every minute or so, or until golden and crisp all over. Remove from the oil, drain on paper towel and dust with icing sugar while hot.

BLUE CHEESE SAUCE

Blue cheese sauce is addictive and will go with just about anything—it's my go-to sauce for all my fried chicken needs. This might seem like a large quantity but trust me, it's worth making more than you think you need.

Makes about 800 ml (27 fl oz)

80 g (2¾ oz) Danish blue cheese
1 tablespoon garlic powder
1 tablespoon onion powder
½ teaspoon ground white pepper
75 ml (2½ fl oz) buttermilk
240 ml (8 fl oz) double cream
240 g (8½ oz) sour cream
175 g (6 oz) whole-egg mayonnaise
2 tablespoons apple-cider vinegar

Add all the ingredients to a food processor and blitz together until smooth and creamy. Transfer to a jar or bowl, cover and store in an airtight container in the fridge until needed (it will keep for 2–3 days).

CAROLINA GOLD SAUCE

The good brown—this sweet and salty number has been labelled the perfect sauce by some. (Well, mainly by my mate Trent, who's been known to practically drink it.)

Makes about 1 litre (34 fl oz/4 cups)

375 g (13 oz) dijon mustard
170 ml (5½ fl oz/⅔ cup) apple-cider vinegar
170 ml (5½ fl oz/⅔ cup) molasses or black treacle
170 ml (5½ fl oz/⅔ cup) honey
1 tablespoon brown sugar
1 tablespoon worcestershire sauce
1 tablespoon hot sauce (see page 80 for homemade)
1 tablespoon tomato paste
1½ teaspoons onion powder
1½ teaspoons garlic powder
1½ teaspoons sweet paprika
1½ teaspoons ground black pepper
½ teaspoon ground turmeric

Put all the ingredients in a bowl and whisk together until smooth, then pass through a fine sieve into suitable sterilised bottles (see page 49). Keep stored in the fridge for up to 3 months.

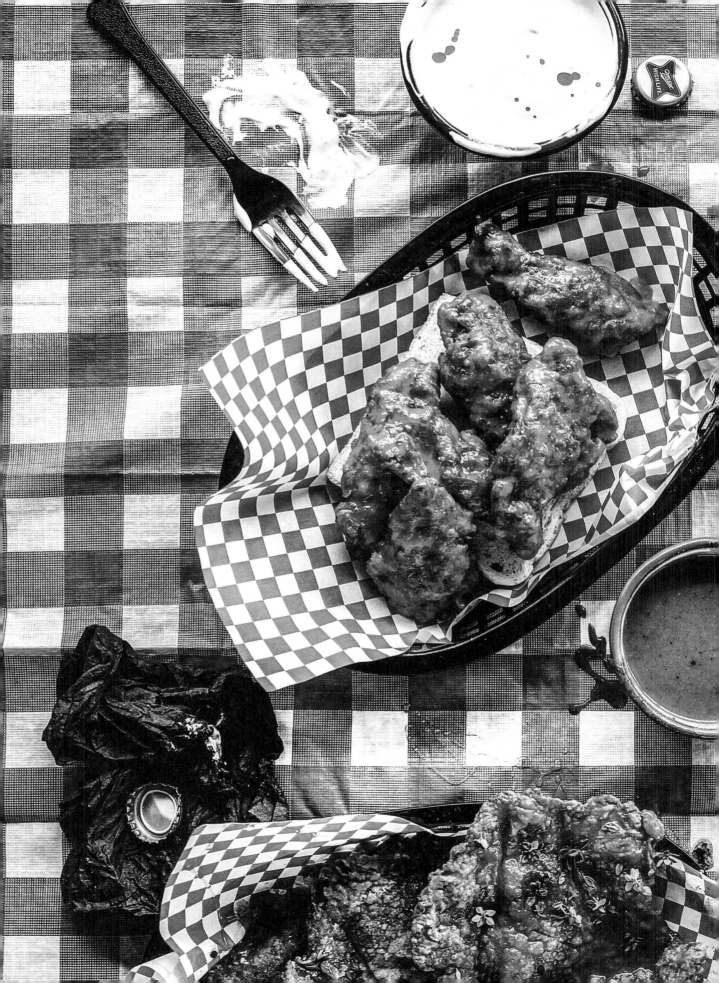

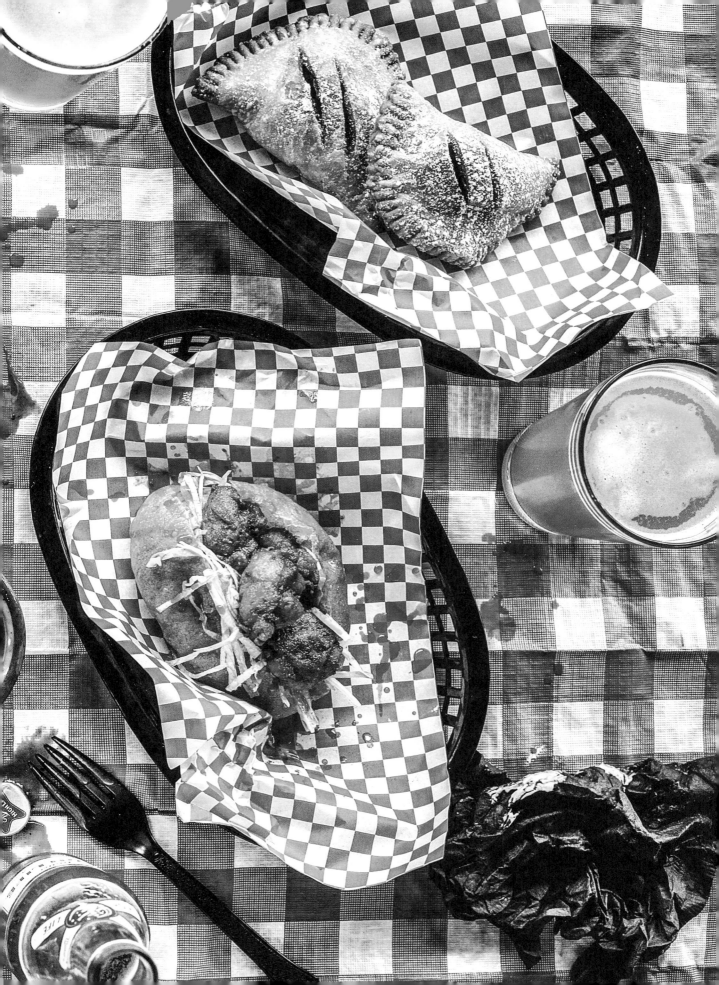

THE HOT CHICKEN PROJECT

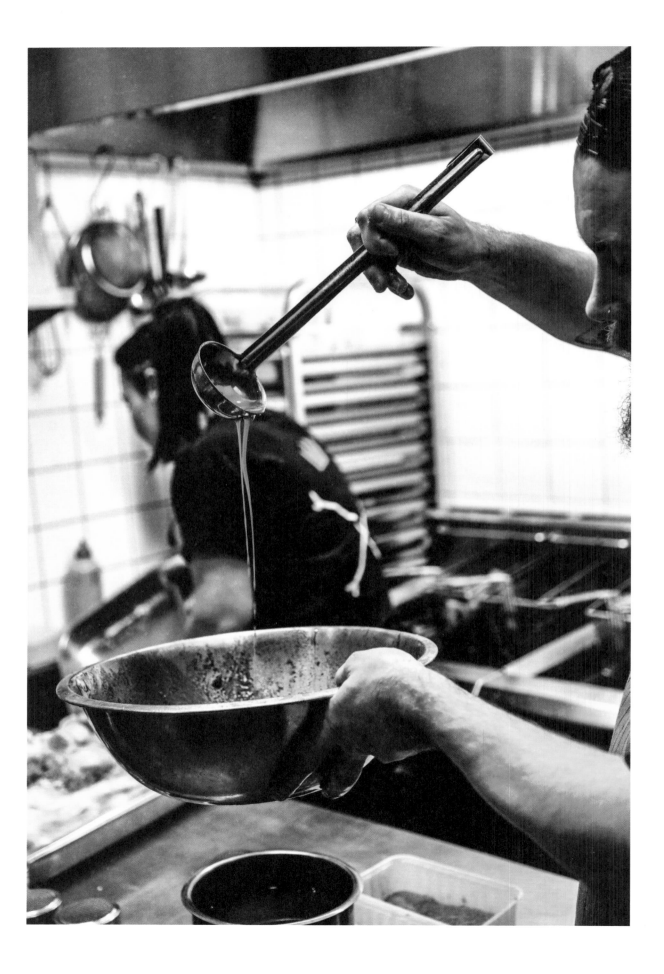

I knew it as soon as I took that first bite of Nashville hot bird—
I was a goner.

My mind had been consumed by the obsessive part of me
that tends to take over in times of wonderment. I had to know
how they did it—how was this stained white Styrofoam plate
sitting half-empty in front of me captivating me in a way that only
three-star dishes had before? How was this piece of bone-in leg
and thigh dark meat, coated in a deep red fiery spice, holding
me spellbound? How was it making my heart beat faster with
excitement and my brain whirl with a thousand questions?

I knew it in that second that something was different, that
what I'd stumbled upon was an awakening. That this plate, now
all but devoured in that neighbourhood out east, was about to
change my life.

I had to figure it out.

How to go about frying that chicken at just the right
temperature for just the right time—not a degree cooler or hotter
or for a second longer.

How to trap those succulent juices beneath that golden
crust so perfectly that it shatters to a musical crunch so that,
with every bite, you know those juices have done their job, that
they have steamed that meat to the perfect texture.

How to create those fiery, cayenne-induced hallucinations,
the beading sweat on my forehead, the watery eyes, running
nose and burning lips.

I was reborn. A fried chicken revival. And it was love—true
love. The obsessive kind. I had to know how it was done, what
made it so goddamn delicious.

How was that bone-in leg and thigh dark meat cooked to
perfection? How were the tenders cooked to the minute yet
still kept so crispy on the outside? And the wings, what kind of
black magic was that—each bite better than the last?

What was the seasoning?

What were the spices?

What do I cook it in? Which lard or oil is the best to use and
which imparts little or no flavour to the fry?

I figured out that it takes the dark meat, bone-in leg and thigh, exactly fifteen minutes at 179 degrees Celsius to cook. Not a minute longer nor a degree hotter. It's by far the longest of the cook times but before it even gets to the cooking stage it's brined and breaded twice over a forty-eight hour period, then, once it comes up to room temperature, it gets a third dusting with the flour before cooking.

And don't worry about keeping the oil at 179 degrees, the open-well fryer will do that for you. Open-well frying isn't like skillet frying, always having to shuffle it around, constantly adjusting the heat source in order to keep the heat consistent. This will just come right up to temperature quicker than you can blink, always keeping that oil heat just right.

And it's an important step, that first drop in. If the oil or lard is at the right temperature you'll see the crust start to form almost as soon as it hits the oil, encasing the joint in a tomb of herbs and spices, the surface sealed tight, which allows the meat to steam within it, rather than stew while cooking, soaking up all the fat from the oil. If it's not done quite right, well, we all know what that's like—just pull into any spinning bucket off the interstate and you'll be reminded.

But if it *is* done right, and the time has been taken over the two-day period leading up to it, it's simple—just a few small details to follow, but the ones that make up the big things, the ones that, if paid attention to, will drive people crazy.

The next puzzle to solve, my favourite to cook, no question about it, and also my all-time favourite to eat. The not so humble chicken wing.

We all know the virtues of a well-cooked chicken wing—crisp, tender and gelatinous. The satisfaction of gnawing and chewing at the bones—extracting those little pieces of fat and flesh stuck between them—is perfection.

It's the attention needed during the process of six minutes and twenty seconds of hot oil acrobatics and ninja-like focus that I love. The key is not to overcrowd your fry basket or skillet, cooking only two serves per basket and shaking every thirty seconds, sometimes having to use your fingers to move

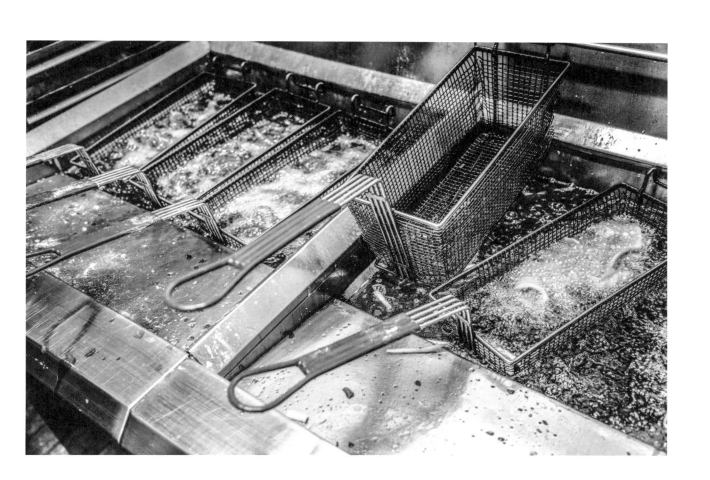

them around the basket, making sure they stay submerged in the cooking oil, the tips of the wings especially, shaking to get that oil flowing around each part of the wing and making sure they cook evenly and don't stick together. That's the key to a good, crispy wing.

The tenders are the easiest and, if I'm honest, probably the most boring to cook. After a drop and a shake if you haven't tried to cook too many at once and overcrowded the basket or skillet they just roll themselves around in the oil or lard and do the work for you. No bone means they are also a quick fry—three minutes and twenty seconds—but getting that crunch just right on a serve of tenders means following the two-day process with methodical precision. You'll soon know if corners have been cut when faced with limp, lifeless pieces of chicken.

Then, of course, there is the all-important pickle—sweet, salty slices of heaven that, if placed on the tongue, like a tab of acid, offer blessed relief.

And there's the white bread, of course, for soaking up all the spices dissolved in chicken grease. Almost the best part of eating a plate of hot chicken is after all the chicken is gone, saving a little bit of the side dish, whichever one you ordered, maybe slaw, maybe braised greens or even fries, and scraping it onto the bread and folding it in half to make what I call a half-slice sandwich. This spiced chicken fat-soaked slice of white bread is as close to late-night-snack heaven as you're ever gonna get.

You see, I came up with a plan after eating and thinking about hot chicken more than was probably advisable.

I was living in Nashville, kinda just wandering around without much to do except eat chicken and drink the sun up in dive bars, juke joints and honky-tonks. Walking the Korean Veterans back and forth, crossing the Cumberland in the blazing heat and freezing cold, day in, day out, hungover, finding my way home from neighbourhoods and apartments. Women and chicken.

I was going to go home. To spread the good word, the Gospel of Hot Bird, to share what I had just discovered.

To scream from the rooftops, "Look what I just found in my hungover haze of self-loathing. You're not going to *believe* how fucking good this is."

NASHVILLE HOT CHICKEN WAS THE SAVIOUR.

"What the fuck is that?" most people would ask me. "Fried chicken? And what the fuck is Nashville Hot Chicken anyway? You're an idiot, that won't work. And I suppose you like country music now? And why do you want to do fried chicken anyway? People want something different from you."

I felt like I was committing High Treason.

You see, I was a burnt-out 2-star chef. People expected more.

And, let's be honest, my first attempt didn't work out, for me, but I was so in love with the idea that I knew I had to do it again, this time on my terms and somewhere I could pay homage to everything I'd witnessed in Nashville.

The problem was, I didn't have enough money to open anything myself. So I called in some friends who I knew would want a place to eat, drink and hang out, just like me.

"I hate restaurants," I texted a friend. "I just need a place I can drink at the bar and get a good piece of fried chicken. Interested?"

There was only one requirement—we had six weeks to find a space and get the doors open, because I had about 500 dollars to my name and my rent was due, so I was starting to feel a little desperate and in need of a good plate of chicken.

A closed run-down dive bar was up for grabs in a street better known for speed deals and late-night violence. Perfect, I thought. I knew once we turned the music up and ignited the fryers people would risk life and limb, if only curious, for a taste and, once hooked, we would be on easy street.

In those six weeks, paint was scraped, floor was laid; we turned an old stage into a kitchen and knocked down a few walls. Our fry times were tested and tested again, the recipes scaled and tweaked.

The Hot Chicken Project was born.

For the most part The Hot Chicken Project is an anti-restaurant, more a halfway house for those afflicted with the love of the bird. A restaurant family made up of misfits, burnouts, troublemakers, second chancers and lifers.

The music's loud. The crowd louder. With fryers crackling, baskets dropping, orders yelling and bowls tossing chicken joints in that glorious fatty mix of powders and spice, it's chicken slingin' in all its chaotic glory.

Hundreds of happy souls wander through each day to get their fix of the Nashville bird. It's a long and skinny place, only a little wider than a trailer—or at least it was before we knocked a few holes in the wall and added a second, bigger half next door to fit the families and hungry groups. We sit proudly in a space about the size of a double-wide.

A copper-topped bar for new-age confession runs the length of the building, lined with worn-out stools that are more function than comfort, a place for drinkers to sit perched with a plate.

The walls are adorned with colourful paintings, a nod to Bolton's, whose walls and windows—covered with caricatures of chickens, a steaming pot of potatoes and a plate of fried chicken, catfish and grouper—somehow survive the constant barrage from the southern sun and, after all these years, still look as vibrant as the day they were painted. And, of course, the painting of Thornton Prince covering the window at Ewing Drive, grinning from ear to ear, a fried drumstick held above his head in victory, leaving little doubt that he is indeed the crowned prince of hot chicken. These paintings are portraits of the dishes' histories. I just wanted to capture a little of my own history here on these walls on the other side of the world.

It must be strange for those who know to see something so uniquely Nashville in the hands of strangers so far from home. It's as close as I could come to what they created all those years ago. I'm just trying to carry the flag and stay as true to the spirit as I can.

Our heats are a gentle build of spices, layers upon layers, southern fried to evil. I couldn't help it, I'm a chef after all, and I may have made things more complicated than needed, to satisfy that urge to add something of myself to the world of hot chicken.

Southern: No heat, just straight-up fried chicken, all herbs and spices, we let that well-seasoned flour do the talkin'.

Medium: Starting to build but mostly mild, a stepping stone to the all-important heat levels but this time disguised with sweet paprika and a few other secrets.

Hot: You'll get a good sweat going with this one. Nothing crazy but if you don't like your food hot it'll catch up with you at some stage. Might not be until the morning, but rest assured it will get you.

So Damn Hot: This is hot, real hot, make you cry kinda hot, the devil is in the detail with three different chillies doing the work, each bite keeping you coming back for more.

Evil: EVIL LIVES HERE was scrawled on the walls when we took over the dive bar, and I took it as a sign. It's chilli on chilli on chilli on chilli and a few other well-hidden surprises. This one will make your kidneys hurt, your lips swell, your nose run and your eyes weep, but that won't stop you eating the entire plate. It's still balanced in flavour but it's not for the faint-hearted. It's addictive as hell and comes with a warning not to touch anything important after eating. I have woken in the middle of the night before, doubled over in pain, kidneys on fire, stomach erupting like a volcano, a pain so fierce you'd do almost anything for it to stop—make a deal with the devil himself if the pain could just ease. Stomach cramps, night sweats, burning eyes, running nose, all leaving you questioning why you even ordered it in the first place. It's at this very moment and for the next few hours and morning to come your body is at the mercy of our evil chicken.

*** I've heard whispers of a pro move embedded in Nashville folklore, a tale told in hushed tones around the shacks and late-night bars, insider knowledge that only the locals know, a fix-all for when you make poor life decisions like ordering a serve of wings EVIL, XXXHOT, EXTRA HOT or SHUT THE CLUCK UP, and it's as simple as this: before you head out for a night of eating hot chicken, put a roll of toilet paper in the freezer. I'm told your future self will thank you, the toilet paper offering cooling comfort when you need it the most, those private moments at 4 am when your stomach starts to tumble and churn.

All of this, everything we do at The Hot Chicken Project, comes from a place of absolute admiration for what those originators of hot chicken have done, and what their families continue to do, a million miles away in the neighbourhoods of Nashville. Our logo, a crown glowing red, a beacon and refuge for all chicken lovers.

I wanted to create a place that was more than just a snap on Instagram. A place with substance, a place that could become part of the community, a place that is about the people. And the food, of course, somewhere that would make those flag-bearers of something so uniquely Nashville proud, something that would honour the legacy that is now set so firmly in Tennessee folklore.

And I didn't want to just take it, all that hard work. That creation. I wanted to share it.

I wanted as many people as possible to experience the same joy it gives me, every bite, still to this day.

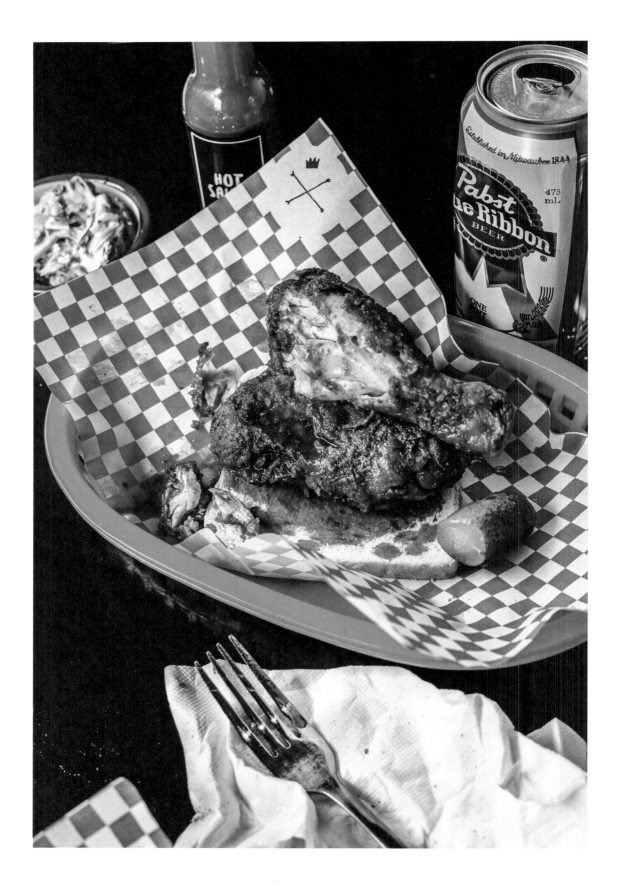

HOT CHICKEN FRIED CHICKEN WITH GRAVY

The trick here is to not throw any of the lard or fat away, as it will make the base of the gravy delicious and rich.

Serves 4

500 ml (17 fl oz/2 cups) buttermilk
1 tablespoon chilli powder
1 tablespoon onion powder
1 tablespoon smoked paprika
pinch of salt
8 chicken thighs or drumsticks
vegetable oil or lard, for deep-frying
cracked black pepper

Spiced flour mix
1 tablespoon sweet paprika
1 tablespoon black pepper
1 tablespoon garlic powder
1 tablespoon dried oregano
1 tablespoon chilli powder
1 tablespoon habanero powder
1 tablespoon table salt
400 g (14 oz/2²/₃ cups) plain (all-purpose) flour
100 g (3½ oz) cornflour (cornstarch)
1 tablespoon hot sauce (see page 80 for homemade)

Mix together the buttermilk, chilli and onion powders, paprika and salt in a bowl. Add the chicken pieces to the bowl and toss to coat, then transfer to the fridge and leave to marinate for 3 hours.

After 3 hours, remove the chicken pieces from the buttermilk mixture and set aside on a plate. Reserve the buttermilk mixture.

To make the spiced flour mix, combine all the ingredients except the hot sauce together in a bowl. Add 3 tablespoons of the reserved buttermilk mixture to the bowl along with the hot sauce and mix everything together with your fingers until the flour mixture starts to form small clumps, then add the chicken pieces and press them into the mixture to coat evenly. Transfer to the fridge along with the reserved buttermilk mixture and set aside for at least 2–3 hours, or until ready to fry.

Half-fill a heavy-based skillet, saucepan or deep-fryer with oil or lard and heat to 185°C (365°F). Carefully lower the chicken pieces into the hot fat, shaking the pan gently so they don't stick together, and cook for 3 minutes on each side. Remove from the pan and transfer to a wire rack to cool, being sure not to throw away the cooking fat as you go.

While the chicken is cooling, make up a white gravy. Add 200 ml (7 fl oz) of the reserved cooking fat to a skillet or heavy-based frying pan, then whisk in the remainder of the spiced flour mix to form a paste. Continuing to whisk, add enough of the reserved chilled buttermilk in a slow, steady stream to form a thick gravy. Season with salt and cracked black pepper. To serve, pile the chicken pieces onto a large plate and pour over the gravy. Dig in.

GOOD PICKLES

No matter what the occasion, a good pickle just can't be beaten. Hungover on the couch? Have a pickle. Salad not quite working? Chop up a pickle and toss it through. A piece of white bread, cheese and pickle is the best quick lunch you could hope for and, let's not forget, fried pickles drowned in ranch is as close to godliness as a bar snack can get.

Now, if you find yourself a good brand of store-bought pickle, then by all means stick with that. But if you do come across some pickling cucumbers, give this a try. Oh, and here's an unnecessary but helpful note: if you have access to vine leaves, try adding one to each jar—the tannins in them will help keep the pickles crunchy.

Makes 2 × 750 ml (25½ fl oz/3 cup) jars

1 litre (34 fl oz/4 cups) water
2 tablespoons rock salt
500 g (1 lb 2 oz) pickling cucumbers
2 garlic cloves, roughly sliced
½ bunch of dill fronds
2–3 teaspoons sugar (optional)

Add the water and salt to a large saucepan and bring to the boil. Remove from the heat and set aside to cool to room temperature.

Pack two wide-mouthed sterilised jars (see page 49) tightly with the cucumbers. Divide the garlic and dill between the jars, pour over the cooled brine and seal tightly with the lids. (If you like your pickles a little sweet, you can add a few teaspoons of sugar at this stage, too.)

Leave the jars somewhere cool and dark for about 7 days, then give one of the pickles a try. If it is salty and sour, then transfer the jars to the fridge; if not, leave the jars where they are and try the pickles again every day until they are. The jars will keep in the fridge until needed.

COLESLAW

The king of summertime salads. I used to hate coleslaw, I really did, but that was when I only knew it as the minced-up pale white paste they would sell at the grocery stores or as a part of your meal at a certain global chicken chain. And, let's be honest, that stuff hasn't really got much better now, has it?

I like my slaw to sit a little while to let all the flavours get to know each other before I dive in, but it's still tasty when it's made five minutes before eating. If you feel the same as me, then make this up a day (or even two) ahead and leave it to chill in the fridge until you need it.

Serves 4–6 as a side

¼ savoy cabbage
¼ red cabbage
1 small fennel bulb
1 small red onion
1 carrot

Dressing
200 g (7 oz) whole-egg mayonnaise
60 g (2 oz) dijon mustard, plus extra if needed
a good splash of apple-cider vinegar, plus extra if needed
pinch of white pepper
pinch of salt flakes

Using a sharp knife or the coarse side of a box grater, roughly shred all the vegetables. (Don't worry too much about precision here; so long as all the different vegetables are roughly the same size that will do.) Transfer to a large bowl and give everything a good mix until all the vegetables are combined.

For the dressing, whisk all the ingredients together in a separate bowl. Taste and add a little more vinegar and mustard if needed (it should taste rich with a good kick of acid).

Spoon the dressing over the shredded vegetables and toss together well. Taste and adjust the seasoning if needed. Serve straightaway or refrigerate until needed.

BEERBQ SAUCE

We always have our usual hot sauces at the bar at The Hot Chicken Project but when the season is right we like to make a few others because, let's face it, life's better with sauce.

This is quite an adventurous one with some strange ingredients like beer wort and wild fennel pollen that you won't always have around the house, but it's worth the effort involved in tracking them down.

Makes 2 × 500 ml (17 fl oz/2 cup) bottles

500 g (1 lb 2 oz/2 cups) soft brown sugar
185 ml (6 fl oz/¾ cup) molasses or black treacle
1 mandarin
1 lemon
1 orange
2 teaspoons pepperberries or red peppercorns
300 ml (10 fl oz) malt vinegar
200 ml (10 fl oz) apple-cider vinegar
750 ml (25½ fl oz/3 cups) beer wort
1 Davidson's plum or other sour plum
5 sunrise limes or regular limes
sprig of wild fennel pollen
3 tinned whole plum tomatoes
½ teaspoon xanthan gum

Add all the ingredients except the xanthan gum to a large saucepan or stockpot. Stirring as you go, bring everything to a low simmer over a low–medium heat. Cook for 20 minutes, then turn off the heat and leave to cool.
 Strain the cooled sauce through a fine sieve into a bowl, pushing firmly on the citrus to extract as much juice as possible. Sprinkle the top of the sauce with the xanthan gum and blend with a hand-held blender until the sauce slowly drips off a spoon. Pour into sterilised bottles (see page 49) and you're good to go. This sauce will keep refrigerated until needed (it'll last for ages).

FRIES AND SEASONING

Make sure you season the fries while hot and straight out of the fryer, as they will take on more of the seasoning that way.

Serves 4

500 g (1 lb 2 oz) frozen crinkle-cut fries
canola oil or lard, for deep-frying

Seasoning
6 whole dried bay leaves
1½ tablespoons dried oregano
1 teaspoon celery seeds
1 teaspoon sweet paprika
200 g (7 oz) salt flakes

For the seasoning, add all the ingredients to a spice grinder and blitz together to a fine powder.
 When ready to cook, half-fill a heavy-based skillet, saucepan or deep-fryer with oil or lard and heat to 180°C (350°F). Add the fries and cook for 4 minutes, or until golden. Transfer to a bowl, adding seasoning to taste, tossing to coat all sides of the fries.

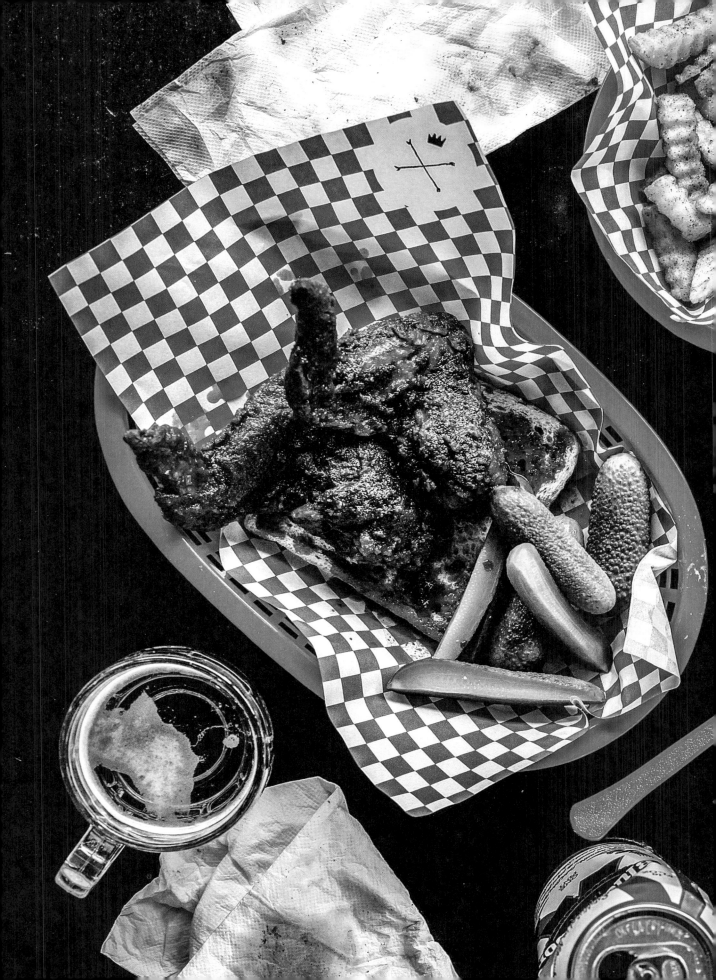

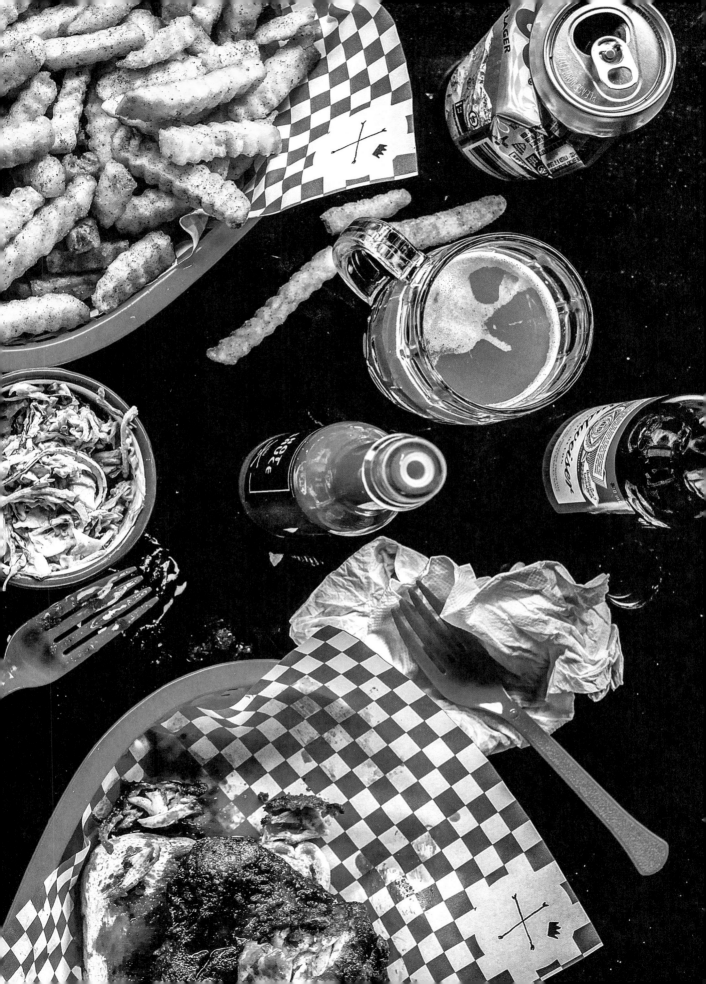

Aaron Turner

Growing up by the coast in Portland, Victoria, Aaron studied graphic design before travelling and working overseas. In 2009 he opened his first restaurant, Loam, in Drysdale, which went on to win numerous awards including Regional Restaurant of the Year in *The Age Good Food Guide 2012* and Regional Restaurant of the Year in *Gourmet Traveller*. Since closing Loam in 2013 Aaron has worked and consulted in Nashville and opened The Hot Chicken Project and IGNI in Geelong. In its first year of business IGNI won Gourmet Traveller's Restaurant of the Year and was awarded two hats by *The Age Good Food Guide 2016* – which it retains to this day – as well as winning the guide's awards for both Regional Restaurant of the Year and Chef of the Year. The Hot Chicken Project can now also be found in Anglesea on Victoria's Great Ocean Road.

Julian Kingma

Julian started his photography career at *The Herald* in 1988 as a cadet. Since going freelance after 10 years as Head Features Photographer for *The Sunday Age*, he has worked for various national and international publications including *Gourmet Traveller*, *Condé Nast Traveller*, *Harper's Bazaar* and *Rolling Stone*. Julian has won Quill Awards for Best Portrait and Best Picture Story, Australian Nikon Photographer of the Year and has exhibited at the National Portrait Gallery in Canberra. He is at his happiest bobbing around on his surfboard in the early hours at Bells Beach, Victoria, near his home on the Surf Coast.

Acknowledgements

Thanks to all the Cooks, Bartenders, Busboys and Dishwashers of Nashville. And to all those who cook to nourish a family or community, or to pay the bills.

To Jules, for always seeing what I'm saying and for capturing my words so perfectly.

To Simon, for believing in the words and seeing it through with me.

To Nancy, for putting up with me through the process and keeping me focused.

To Jane and the crew at Hardie Grant, for allowing me to find a voice in the world of publishing.

To Vaughan at Neighbourhood Creative, and to Mays for being the worst travel PA ever—for the comic relief and being the designated drunken navigator.

Finally, a big thanks to Music City Tourism and SoBro Guest House for putting us up in the heart of Nashville to help this book come to life.

Published in 2020 by Hardie Grant Books, an imprint of Hardie Grant Publishing

Hardie Grant Books (Melbourne)
Building 1, 658 Church Street
Richmond, Victoria 3121

Hardie Grant Books (London)
5th & 6th Floors
52–54 Southwark Street
London SE1 1UN

hardiegrantbooks.com

 A catalogue record for this
book is available from the
National Library of Australia

The Hot Chicken Project
ISBN 978 1 74379 484 5

10 9 8 7 6 5 4 3 2 1

Publishing Director Jane Willson
Managing Editor Marg Bowman
Project Editor/Editor Simon Davis
Design Manager Jessica Lowe
Designer Vaughan Mossop, NBHD Creative
Photographer Julian Kingma
Stylist Karina Duncan
Production Manager Todd Rechner
Production Coordinator Mietta Yans

Colour reproduction by Splitting Image Colour Studio
Printed in China by Leo Paper Products LTD.